First published in 1997 by:
Middlesbrough Borough Council
Community Development, Leisure and Libraries Department
Vancouver House
Central Mews
Gurney Street
Middlesbrough TS1 1EL

in association with:
Lund Humphries Publishers Limited
Park House
1 Russell Gardens
London NW11 9NN

British Library Cataloguing in Publication Data
A catalogue record of this book is available from the British Library

ISBN 0 85331 708 9

Distributed in the USA by:
Antique Collectors' Club
Market Street Industrial Park
Wappingers Falls
NY 12590
USA

Made and printed in Great Britain by:
BAS Printers Limited
Over Wallop
Stockbridge
Hampshire SO20 8JD

Authors:
Richard Cork
Claes Oldenburg / Coosje van Bruggen
Peter Davies
Tony Duggan
Les Hooper

Editor:
Tony Duggan

Design:
Spring House Design Associates
Slaley, Hexham, Northumberland NE47 0AW

Generous financial support for this publication has been given by the
Henry Moore Foundation and Teesside Development Corporation.

Bottle of Notes
Claes Oldenburg / Coosje van Bruggen, 1993
Painted steel, 30 × 16 × 10ft (9.14 × 4.88 × 3.05m)
Central Gardens, Middlesbrough, England

bottle of notes

Claes Oldenburg
Coosje van Bruggen

Text by Richard Cork

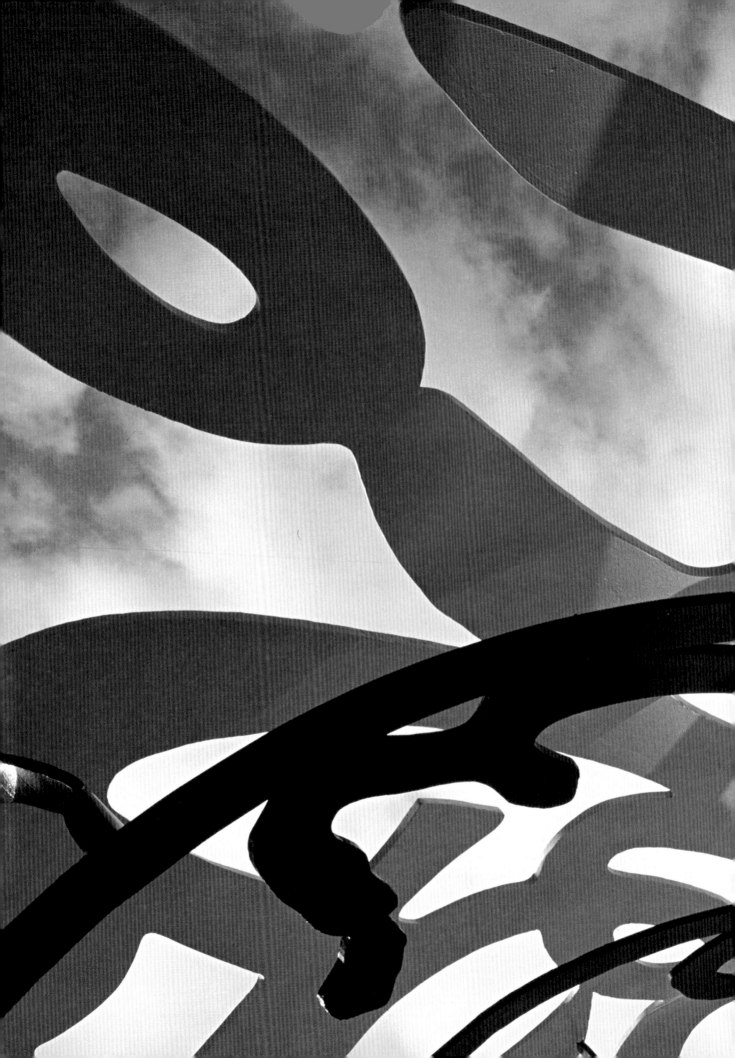

Contents

Foreword

The Lord Palumbo of Walbrook, Chairman of the Arts Council of Great Britain 1989–94

Bottle of Notes was commissioned by Middlesbrough Borough Council and is the first public sculpture in the United Kingdom by the renowned artist partnership of Claes Oldenburg and Coosje van Bruggen. Oldenburg and van Bruggen have produced works in Chicago, Des Moines, Las Vegas, Philadelphia, Dallas, Los Angeles, Barcelona and Düsseldorf, and this new addition to their prestigious list of large-scale projects puts Middlesbrough into a truly international context.

The benefits of art in public places are well documented. It increases audiences; attracts new sources of funding; provides opportunities for the employment of artists, craftspeople, technicians, suppliers, manufacturers of material, and transporters. It generates media attention thus provoking debate; it increases the attraction and interest in a locality thereby increasing its usage by the public. Crucially, it makes contemporary arts more accessible, and in *Bottle of Notes* the North East in general and Middlesbrough in particular are fortunate indeed in having such an extraordinary stimulus in the creation of a richer visual environment.

The town has a long and well established tradition of working with iron and steel and it is proudly associated with grand metal structures throughout the world. It is entirely fitting, therefore, that *Bottle of Notes* should finally 'wash up' on the banks of the River Tees; a testament to the expertise of the region's workforce and to the Borough Council's reputation as one of the most enlightened and forward-thinking authorities in the country in support of public art.

Bottle of Notes represents an inspiration to artistic vision, a spur to partnership and collaboration and a catalyst for change and development. It constitutes a new benchmark for public art in Britain and provided an important marker for the UK Region of the Visual Arts festival in 1996, which was part of the Arts 2000 scheme launched by the Arts Council in 1991 to celebrate Britain's artistic achievements and to lay the foundations for cultural life in a new millennium. To all of the sponsors, fabricators and project officers who have been involved in the realisation of this masterwork, and most particularly to Claes Oldenburg and Coosje van Bruggen, I offer my warmest congratulations and gratitude.

Introduction

Tony Duggan and Les Hooper

The *Bottle of Notes* is a further milestone in the development of public art in the north east of England. Through the vision of Northern Arts and in particular Peter Davies, Head of Visual Arts, and Les Hooper, Commissions Agent, the area has since the early 1970s been at the forefront of National Public Art activity.

In the mid-seventies, Northern Arts started to address issues of how artists could contribute to society. One concern was how the artist could influence the environment and in particular how public art could be advanced in the northern region. This took several forms, including the establishment of major residencies by contemporary artists at Durham Cathedral and Grizedale Forest, for example, initiated by Peter Davies in 1977. The Grizedale artists and the philosophy of buying time rather than work from the studio provided a means to address the urban landscape. This was at a time when there was very little going on outside the gallery.

Northern Arts developed a close working relationship with the artists, and the appointment of Les Hooper, working freelance to Northern Arts, increased the profile of public art in the region. New contexts were explored such as *Art in the Metro,* but it became clear that strategic planning and an enabling policy were required. The strategy was to concentrate on major public art projects and to develop models of practice. Experience gained was then fed back to the visual arts constituency and to the building, landscape and planning professions. Inevitably there was a close working relationship with Local Authority Architects and Planners as most of the significant development in the northern region, one way or another, involved public money.

Gateshead Metropolitan Borough and Middlesbrough Borough Council were the most enthusiastic supporters. Gateshead was at the start of a programme of commissioning a number of ambitious sculptures on the banks of the Tyne. At one time Northern Arts, indeed, had considered the suggestion of an Oldenburg and van Bruggen commission there. Middlesbrough, though, with a strong history of commissioning public art during the previous decade, became the obvious choice. Gateshead and Middlesbrough's interest in public art helped establish a regional development plan with the main emphasis on the river corridors of the Tyne, Wear and Tees, which house the major urban conurbations of north east England.

The eighties saw a very fast acceleration of what has become known as public art, not only in the northern region, but throughout the UK. This was manifested in many forms, from environmental artwork projects and community festivals, to the artist placements of Artist Agency, or the temporary installations and events of Projects UK. Northern Arts' successful advocacy had seen the establishment of public art policies in local authorities, the appointment of public art officers and an emergence of new public art agencies. There was also the establishment of Percent for Art schemes. Northern Arts consequently changed from being an instigator of commissions – and the *Bottle of Notes* is a fitting and final testament to this role – to a policy of supporting others.

Northern Arts was determined to raise the stakes in public commissions. In the mid-eighties there were few major commissions, and even fewer offered to international artists. Northern Arts wanted to set a new benchmark of quality. Oldenburg was an early and natural choice to invite to commission. Peter Davies had seen his early large sculptures in the United States, and the wit and accessibility of the work was universally appreciated. The commission therefore came from a public art drive. However, Peter Davies was well aware that his friend Tony Knipe, then Director of Sunderland Arts Centre, was organising the first UK exhibition of Oldenburg's work for seventeen years, and that the exhibition would be based on the large-scale work of Oldenburg and van Bruggen. This provided an ideal platform and opportunity to initiate a commission. Claes Oldenburg made his first visit to Middlesbrough with Peter Davies and Tony Knipe in July 1986, and a presentation was subsequently made to Middlesbrough Councillors and Officers.

At this pre-National Lottery Fund time, much thought was given to how such a sculpture could be paid for and realised. It was known that the sculpture would have to be made of steel, as this industry has played such an important role in the economy and history of the region. Middlesbrough took the leap of faith needed to start the commissioning process without knowing the final image – a very brave decision by a local authority. Much of the subsequent delay in the project, which had initially incorporated a job creation and training element, was due to changes in government employment and training policy. Les Hooper, who had left Northern Arts to establish Sculpture North (which later evolved into Pedalling Arts), was eventually contracted by Middlesbrough to undertake the hands-on project management.

This publication charts the passage of the *Bottle of Notes,* which culminated in the presentation of the sculpture to the people of Middlesbrough by Lord Palumbo on 24 September 1993.

During 1987 the artists developed the idea of the *Bottle of Notes* in conjunction with finalising plans for the exhibition and accompanying publication, which was to be titled *A Bottle of Notes and Some Voyages*. An essay from this book is reprinted as part of this publication, in addition to a new critical appraisal of the sculpture by Richard Cork, Chief Art Critic of *The Times*, London. Fabrication of the *Bottle of Notes* was a monumental task in itself and the final part of this publication documents the making of the sculpture, which continues the legacy of the town's Ironmasters. A Selected Biography, courtesy of David Platzker, documents the work of Claes Oldenburg and Coosje van Bruggen.

Since the installation of the *Bottle of Notes*, interest in the project has been immense. Middlesbrough Council has won the prestigious British Gas Award for Art in Public Places, the Northern Electric Champions Award and was runner-up in the National Art Collections Awards. A documentary *Getting the Message* was produced

by Peter Chapman for Tyne Tees Television, which further reinforced the positive message of the sculpture and the place.

The *Bottle of Notes* has helped to raise the artistic profile of the northern region, which has been recognised in it being appointed national host of Arts 2000, Year of Visual Art in 1996. In more than one way the sculpture is a landmark, a symbol for change and a catalyst for new cultural activity.

The *Bottle of Notes* could not have been achieved without the partnership of a number of organisations and individuals. The elected members of Middlesbrough Council showed the foresight and vision to proceed with the commission, and their courage has been rewarded by national recognition of the importance of the *Bottle of Notes*. Tony Noble, Chief Economic Development and Planning Officer, Middlesbrough Council; Les Hooper, Sculpture North; Peter Davies, Northern Arts; and Tony Duggan, Planning Officer, Middlesbrough Council, steered the project through what, at times, was a difficult journey. AMARC in Middlesbrough and Hawthorn Leslie Fabrication Limited realised the artists' ambitions in making the sculpture.

Northern Arts initiated the commission and provided financial underpinning and drive to enable it to happen. Apart from grant aid, Northern Arts sold Claes Oldenburg's two maquettes for the *Bottle* to Leeds City Art Gallery to help realise the project. Northern Arts provided Officer support and worked closely with Middlesbrough Council to achieve the commission. Other generous support was provided by British Steel, The Foundation for Sport and the Arts and a number of other companies. This publication has received support from the Henry Moore Foundation and Teesside Arts Awards.

Notes towards a Large-scale Project for Middlesbrough
from *A Bottle of Notes and Some Voyages* (1988)
Claes Oldenburg and Coosje van Bruggen

The ingredient of the Middlesbrough site which most captured our imagination was the history of Captain Cook, whose birthplace and museum is advertised as an attraction of the area called 'Cook's Country' in the brochures. Captain Cook made us think of Captain Gulliver and his imaginary explorations earlier in the eighteenth century. For a while we tried out the idea of a sculpture based on the examination of Gulliver's pockets but to be called 'Cook's Pocket'. Coosje was later to read in Captain Cook's journals that the natives he encountered liked to pickpocket the explorers. But neither the objects obtained from Gulliver's pockets nor from the pockets of Cook's men (for example, a spyglass, a snuffbox) then seemed to us adaptable to a sculpture for the site, and only the idea of a container carried over to the next development. We had considered some kind of a vessel, for example, a shipwrecked sailing ship, but this subject required simplification and some connection to the idea of scale. We were reminded of Edgar Allan Poe's 'Ms. Found in a Bottle'. A bottle is a kind of ship, and ships are often built in a bottle. This provided the Swiftian reversal which authorized a very large bottle, or one as large as a civic sculpture needs to be, and so the bottle took the place of the sailboat.

One of the problems of the pocket subject had been its opacity, which could be solved by treating it as a cargo net, or, recalling Gulliver's net purse, in a way that the contents would be open to view. In a bottle the problem doesn't exist, but the net structure suggested a way to move from the object into the area of sculpture: instead of containing sheets of paper on which there was writing (another item from Gulliver's pocket), the bottle would be 'made of writing'. The paper would disappear, leaving only the script. The idea of a sculpture defined by lines occurs in Oldenburg's *Batcolumn*, in a more geometric way, as well as in the famous transporter crane over the Tees at Middlesbrough. We decided to use both our 'hands', which are quite different. I would do the drawing / writing surface of the *Bottle* in an angular style with ink blots, using some lines from Captain Cook's journals, in one colour. Inside would be a spiralling structure made of Coosje's rounded script in another colour, using a more personal text. We felt there should be a 'cork' in the *Bottle*; this would be the only solid part of the sculpture.

So far we have not brought the proposal into contact with the actual conditions of the site, but we visualize a scale of about twenty-nine feet in height, which would make it almost eleven feet in diameter. The *Bottle of Notes* should be leaning at about the angle of the Tower of Pisa, as if stuck in sand by a receding wave. The surface could be a gravel plot within a park situation, preferably with a bit of slope, perhaps near to some water.

Opposite and above: Claes Oldenburg and Coosje van Bruggen.

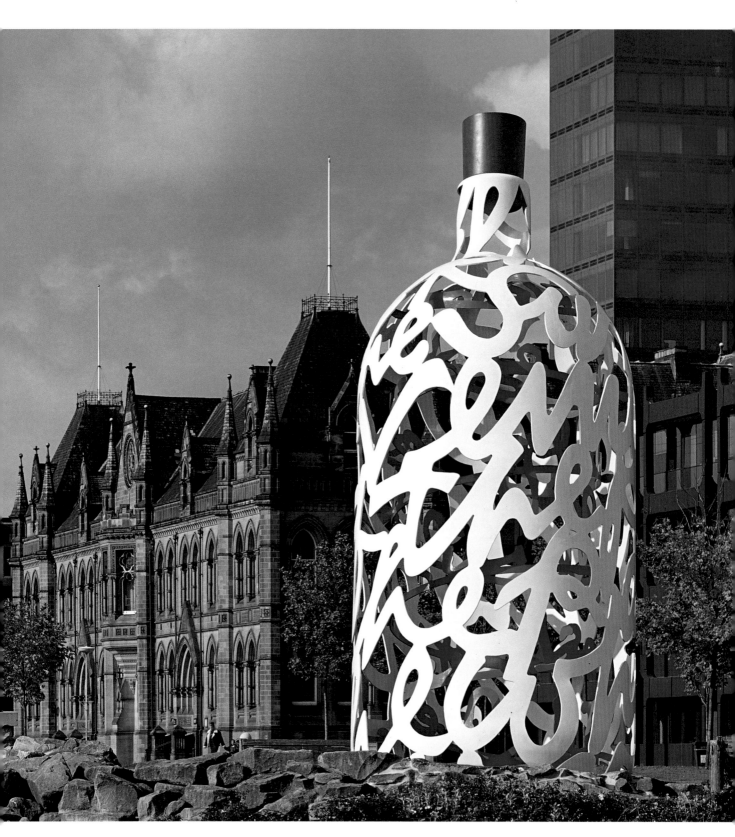

Message in a Bottle
Richard Cork

Making monumental sculpture for a civic site is an enterprise fraught with potential pitfalls. Conscious of the need to relate the work to its locale, both formally and thematically, the artist may end up honouring the context in too literal or dutiful a manner. The outcome could become so divorced from its maker's authentic imaginative concerns that banality sets in. Fears harboured by members of the commissioning body often exacerbate the problem, especially when they insist on a work devoid of controversy. In their anxiety to evade public disapproval, they err on the side of timidity.[1] As a result, the sculpture assumes such an inoffensive form that it degenerates into blandness. Unable to provoke a strong reaction of any kind, the sanitised object remains a matter of supreme indifference to its supposed audience. It merges tactfully with the surroundings, unnoticed even by people who walk past on an everyday basis.

Bottle of Notes avoids these dangers with irresistible aplomb. Nobody encountering the sculpture will be able to ignore its flamboyant and brazen presence. Soaring nearly thirty-five feet in the northern air, and tilted at an angle almost as startling as the Tower of Pisa, this bizarre apparition in tempered steel is bound to trigger a host of questions. Why has an outsize bottle been chosen for such a prominent setting, in the newly refashioned centre of Middlesbrough? What is the meaning of the notes themselves, one sentence wrapped like a lattice around the bottle's circumference and the other spiralling crazily upwards inside the sculpture? How did the artists responsible for making such an unexpected image convince the municipal authorities that it would be a suitable landmark for their town? And why does the bottle lean so vertiginously, as if buffeted by a gale to the point of outright collapse?

No one could have guessed, when Claes Oldenburg and Coosje van Bruggen were first invited to consider the commission, that it would take so unpredictable a form. Middlesbrough is essentially a heavily industrial centre, dominated by gargantuan chemical and steel factories suffused with smoke. The two artists might have been expected to react to the most visible characteristics of a town still shaped by the legacy of the formidable Victorian Ironmasters whose ambitions prompted William Gladstone, on a visit in 1862, to describe it as 'an infant Hercules'.[2] But instead of taking their principal cue from the machine-age prowess of the Transporter Bridge, which became the most celebrated local landmark after it was built in 1918, they grew far more fascinated by Captain Cook. For he was born at Marton in 1728, and the Cook Birthplace Museum in Stewart Park contains an abundance of material about the pioneering maritime voyages carried out by a man proudly described in the museum's catalogue as 'the greatest navigator the world has known'.[3]

Whether or not Oldenburg agreed with this patriotic assessment, he found his imagination stirred by the history of the prodigious captain on his first visit to Middlesbrough in July 1986. The town was completely unknown to him, and even at

Captain Cook's Text for Bottle of Notes, 1988.
Felt pen and pencil.
25³/₈ x 35¹/₂ ins (64.5 x 90.2cm).
Collection of Claes Oldenburg and Coosje van Bruggen.

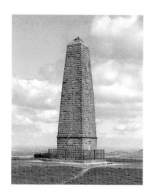

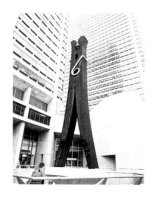

this early stage, Cook's exploits appealed more powerfully than any other aspect of the locality. Even so, there was never any possibility that a straightforward monument to the navigator would result. An abundance of such objects have long been standing in the area, after all. Near the museum itself, and marking the site of the cottage where he was born, a granite urn was erected by the redoubtable Ironmaster Henry Bolckow at the height of Middlesbrough's burgeoning early prosperity in 1858. It looks almost funereal compared with the conventional bronze statue of the captain, standing with legs heroically apart and instruments in his hands, on a plinth overlooking the sea at Whitby, where he was apprenticed to a shipowner in his youth.[4]

But the most awesome and enigmatic of the Cook monuments is the obelisk on Easby Moor, rising fifty-one feet into the sky from the highest point of the Cleveland Hills. Probably the largest memorial to the captain in the world, even outstripping its counterparts in New Zealand and Hawaii, it testifies above all to the navigator's aspiring fortitude.[5] In that sense, the Easby monument is far more eloquent than the cottage inhabited by Cook's father at Great Ayton, dismantled in 1934 only to be re-erected wholesale in Australia. This farm-labourer's dwelling says nothing about the obsessive determination which impelled an utterly singleminded man to make his hitherto uncharted journeys.[6] The obelisk, by contrast, symbolises both his toughness and his stubborn desire to transcend the perceived geographical limits of the period.

However much Oldenburg may have warmed to the captain's doughty resolve, neither he nor van Bruggen wanted their sculpture to be seen simply as a monument to a particular Empire-building individual. Rather did they aim at a more freewheeling meditation on the theme of exploration, fired no doubt by the indirect yet felicitous links between Cook and Jonathan Swift. First published only two years before the captain's birth, *Travels into Several Remote Nations of the World by Lemuel Gulliver* has been something of a talisman to Oldenburg for over thirty years.[7] He has played around with scale as blithely as Swift himself, who delighted in dispatching his itinerant hero to countries where the size of everything underwent an astounding transformation. Oldenburg's love of expanding mundane objects to colossal dimensions prompts in the viewer the sense of wonder felt by the diminutive people of Lilliput when they explored the towering Gulliver and, 'in a large Pocket on the right Side of his middle Cover', found a bewildering implement:

> *'we saw a hollow Pillar of Iron, about the Length of a Man, fastened to a strong Piece of timber, larger than the Pillar; and upon one side of the Pillar were huge Pieces of Iron sticking out, cut into strange Figures; which we know not what to make of.'*[8]

Gulliver's pocket-pistol undergoes a metamorphosis, just as a washstand or a three-way plug is changed from everyday familiarity to marvellous strangeness in

Oldenburg's early sculpture. His work is as subversive as Swift's, and both he and van Bruggen identify with the notion of Gulliver as an inveterate discoverer who generates unexpected and often startling new images in his voyages round the world. They aim at a similar form of eye-opening disruption when planning and then attempting to execute their large-scale projects in different countries. Sometimes, the ventures never reach completion – perhaps because, as Oldenburg admits, 'we strayed too far from the reality principle; but we would rather risk rejection than put restraints on our imaginations'.[9]

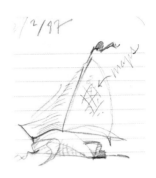

Cook probably harboured a similar strain of audacity within his complex temperament. Any explorer must be prepared to deal with hazards, and when the captain set sail in *HMS Endeavour* on his first voyage of command in 1768 he would have realised that the expedition might easily founder. Maybe that is why several of Oldenburg's earliest drawings for the Middlesbrough commission, in February 1987, took the form of a shipwreck sculpture. On one page, a ship apparently belonging to the same era as the *Endeavour* lurches to one side in a buffeting wind, its sail emblazoned with maps outlining the journey ahead. But the mood darkens in a related drawing where the ship has become ominously skeletal, with a shrunken sail and timbers so twisted that they scarcely seem capable of withstanding the waves.

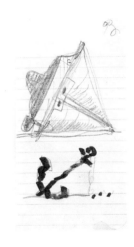

Nemesis arrives on another sheet drawn at that time, where the ship has already keeled over and come to a melancholy rest on rocks or a beach. The anchor defined with bold strokes of orange felt pen below looks equally mournful, but neither of these despairing images could have satisfied Oldenburg and van Bruggen for long. He relishes the idea of intrepid maritime voyaging so much that, when moving to the west side of Manhattan in the 1970s, he saw his new studio as a ship. Taking over premises formerly belonging to the Maritime Engine Specialities Corporation, filled with wooden models of propellors and other parts, he was delighted to find that the words 'Ahead' and 'Astern' had been inscribed on the controls of the room-size elevator. The building's nautical association is, according to Oldenburg,

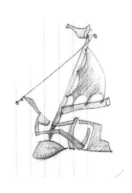

> '*felt strongly in the late afternoons when the inhabitants are as sealed off from the surroundings as on a ship at sea, because of the thousands of honking cars and trucks trying to force their way into the nearby Holland Tunnel, our link to mainland America. And also during nights of high wind, when the plain maple boards of the floors, laid like decks over raw wooden beams, creak like a rolling hull.*'[10]

Notebook Page – Studies for a Shipwreck Sculpture, *1987 (details). Pencil, coloured pencil, felt pen, ball-point pen. Three sheets: 2¹³/₁₆ x 2¾ ins (7.1 x 7cm), 2¾ x 2⅛ ins (7 x 5.4cm) and 5 x 2¾ ins (12.7 x 7cm) on sheet 11 x 8½ ins (28 x 21.6cm). Collection of Claes Oldenburg and Coosje van Bruggen.*

For two artists who feel as if they are at the helm of such a vessel, developing their ambitious projects with techniques 'purposely kept on the primitive level of Robinson Crusoe',[11] the shipwreck image must have seemed defeatist after a while. At all events, it was discarded. So was the idea of a sculpture inspired by the Lilliputians'

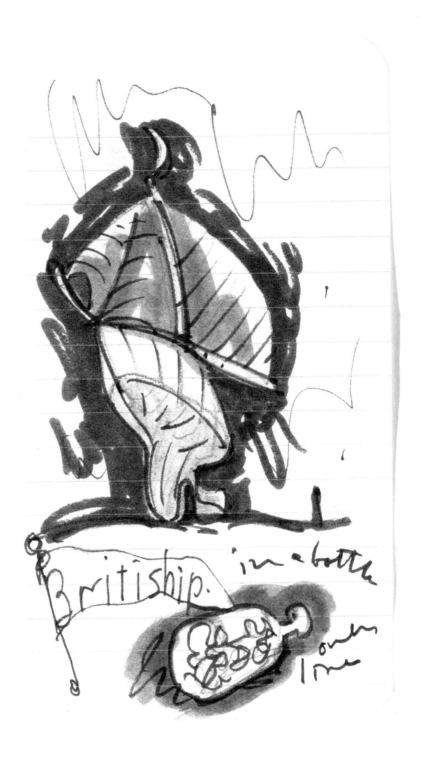

Notebook Page – 'Britiship' and
Bottle with Writing, *1987 (detail).*
Pencil and felt pen on paper.
One of a pair of drawings:
5 x 2²/₄ins (12.7 x 7cm) each on
sheet 11 x 8¹/₂ ins (28 x 21.6cm).
Collection of Claes Oldenburg and
Coosje van Bruggen.

examination of Gulliver's pockets. Although there was a link between this incident and Cook's description in his journals of the natives who enjoyed picking his pockets, the objects most likely to be found inside them – a spyglass, pistol and snuffbox – did not lend themselves to a sculptural transformation.

The notion of the pocket as a container did, however, help to nourish the emergence of the final image. One of Oldenburg's notebook drawings juxtaposes a galleon in full sail with a bottle lying on its side. He calls the vessel 'Britiship', as if to suggest that the island where Cook was born could be seen as a seagoing craft. After all, Swift imagined Laputa as 'An Island in the Air, inhabited by Men, who were able (as it should seem) to raise, or sink, or put it into a progressive Motion, as they pleased'.[12] Compared with this invention, the idea of Britain as a ship seems positively restrained. But the image was rejected, doubtless because it seemed over-elaborate, and attention now came to be concentrated on the bottle instead.

Judging by Oldenburg's previous work, such a container had possessed considerable appeal for several decades. As early as 1956, he brushed in a drawing of three small objects: a razorblade, a nutshell and a bottle cap. They are all picked out by lights on an apparently nocturnal ground, and their discarded appearance recalls a sentence from Oldenburg's grand, Whitmanesque statement published by the Martha Jackson Gallery five years later: 'I am for the art of things lost or thrown away, coming home from school'.[13] Of these three *objets trouvés*, the most prominent and luminous is the bottle cap. It lies there, gleaming like a moon in the night sky.

As if to reveal where the cap once belonged, Oldenburg also drew a study of an *Ink Bottle* in the same year. Executed with an unusual amount of painstaking detail, it stands upright and open against a dimly lit wall reminiscent of Morandi's etchings. At this stage, the drawing contains no hint of a desire on the artist's part to enlarge the bottle to colossal dimensions. The dark container is defined with a modesty which Morandi might well have cherished, and only in 1987 did Oldenburg finally get around to producing an outsize *Broken Bottle with Label Fragment* as one of the sculptures in his *Haunted House* installation at the Museum Haus Lange in Krefeld.[14] Displayed upside down, its splintered ends stick up like the fragments projecting from the frozen water in Caspar David Friedrich's masterpiece *The Sea of Ice*. A tilted galleon lies in Friedrich's painting as well, uncannily foreshadowing the early drawings for *Bottle of Notes*. But the *Broken Bottle* at Krefeld stood erect on a wooden floor in a supposedly abandoned house, where all the windows had been smashed. With objects as macabre as an uprooted birdhouse and a rotten apple core its only companions, the bottled testified to an autumnal strain in Oldenburg's imagination. Monumental they may be, but these relics show how an awareness of vulnerability and decay has gathered force in his work as he grows older.

Intimations of mortality likewise play a part in *Bottle of Notes*, which gradually assumed its form during the year in which *The Haunted House* ensemble went on

Below:
Ink Bottle, *1956. Ink on paper.
11 x 8¹/₂ ins (28 x 21.6cm).
Collection of Claes Oldenburg and
Coosje van Bruggen.*

Bottom:
Broken Bottle with Label
Fragment, *1987.
Expanded polystyrene, canvas
polyurethane resin and latex paint.
70 x 48ins (177.8 x 121.9cm)
height and diameter.
Collection of Claes Oldenburg and
Coosje van Bruggen.*

display. But another factor contributing to the ominous side of the Middlesbrough sculpture derives from Edgar Allan Poe rather than Oldenburg's consciousness of age. While thinking about the bottle's possible contents, van Bruggen remembered the *Tales of Mystery and Imagination*. Poe is one of her favourite authors, and his macabre 1831 story 'MS. Found in a Bottle' centres on a hapless sailor who, on the point of drowning in a hurricane-battered craft, is swept on board a passing vessel of Oldenburgian dimensions. He cannot understand how this nightmarish apparition, 'a gigantic ship, of perhaps four thousand tons', manages to bear up 'under a press of sail in the very teeth of that supernatural sea'. But the galleon's bulk vastly outstripped anything the sailor had seen. 'Although upreared upon the summit of a wave more than a hundred times her own altitude', he wrote, 'her apparent size still exceeded that of any ship of the line of East Indiaman in existence.'[15]

Once on board, the sailor was even more astounded to discover that the eerily wrinkled crew passed him by unnoticed. His invisibility meant that he could enter the captain's private cabin and take the writing materials which enabled him to set down this account of the ordeal. 'It is true that I may not find an opportunity of transmitting it to the world', he concedes, 'but I will not fail to make the endeavour. At the last moment I will enclose the MS. in a bottle, and cast it within the sea.'[16] He may not have been given the opportunity to do so. While its crew glided 'to and fro like the ghosts of buried centuries', the ship plunged into a region still more terrifying than before. 'All in the immediate vicinity of the ship is the blackness of eternal night, and a chaos of foamless water', wrote the sailor, 'but, about a league on either side of us, may be seen, indistinctly and at intervals, stupendous ramparts of ice, towering away into the desolate sky, and looking like the walls of the universe.'[17] Poe's gothic fantasy had reached its awesome climax, and soon the vessel was caught in a lethal vortex. The horrified narrator described how

> 'the ice opens suddenly to the right, and to the left, and we are whirling dizzily, in immense concentric circles, round and round the borders of a gigantic amphitheatre, the summit of whose walls is lost in the darkness and the distance'.[18]

Poe never bothered to explain how the disorientated sailor could have continued writing his journal in such a cataclysm. But readers are meant to suppose that he did so until the moment when the ship started quivering and finally went down. Somehow, the man stuffed his miraculously unblotted manuscript into the bottle before he died. And for all its shameless implausibility, the act of committing this last testament to the sea carries a potent charge. The bottle becomes a substitute for a ship, carrying its message to an unknown destination. The words may never be found by anyone, but at least the attempt has been made in a desperate, oddly idealistic

move – the literary equivalent of a gambler's final throw of the dice.

Although Oldenburg and van Bruggen knew from the start that their *Bottle* would be seen, and in a specific location, they could not be confident of its reception. In this respect, the Middlesbrough sculpture was a hazardous venture, even if it has nothing to do with the morbid melodrama of Poe's story. The sailor's grand act of faith must have appealed to the artists as they developed their project, and they incorporated the form of Poe's vortex in their sculpture. More significantly, they ensured that writing played a powerful role, too. But rather than following the example of the sailor and push the message inside the bottle, they decided with great daring to let the words take over the entire object.

How could writing become viable in sculptural terms, though? It was a major problem. On the notebook page containing the drawing of 'Britiship', Oldenburg represented the words as a scribble. They look anarchic, and the bottle form is tautly defined with contours uninterrupted by the illegible jumble of text. To the right of this little sketch, however, Oldenburg wrote 'only line'; and those two words offered a way through to the structure of the final sculpture. On another notebook page, he took a reproduction of Nathaniel Dance's celebrated painting of Cook[19] and cut out a detail of his hands holding a map. Using a felt pen, Oldenburg scrawled lines across the paper as if in preparation for the words he and van Bruggen would write on the bottle.

The wildness of these lines may seem surprising, in view of the importance attached to particular words and their meaning in the final sculpture. But the scrawl surely has links with the fascination Oldenburg felt, on first coming to New York in 1956, with what he later called

> *'the agitated writing on the surface of the city: the walls, the streets, every place that could be marked. Graffiti had not yet become self-conscious or stylized; these were anonymous messages of experience and survival'.*[20]

Although the messages in *Bottle of Notes* would turn out to be far from anonymous, they likewise speak in their own way of 'experience and survival'. In those early years Oldenburg copied graffiti, and produced rawly executed monoprints and posters inspired by street writing which he then put up in the city. He also made constructions out of the words, deploying the formats of newspapers and buildings. More, perhaps, than most artists, Oldenburg responds to writing. He studied English literature at Yale in the early 1950s, and his first job after leaving university was a two-year stint as an apprentice reporter at the Chicago News Bureau. So incorporating verbal material in a sculpture must have seemed a natural, even inevitable step, and van Bruggen's long involvement with writing poetry and criticism doubtless reinforced their joint commitment to the words in *Bottle of Notes*.

Top:
Notebook Page – Cook's Hands,
1987 (detail).
Clipping with felt pen.
2³/₄ x 4 ins (7 x 10.2cm) on sheet
11 x 8¹/₂ ins (28 x 21.6cm).
Collection of Claes Oldenburg and
Coosje van Bruggen.

Above:
Ray Gun Poster, *1961.*
Sprayed oil wash on torn paper.
24 x 18 ins (61 x 45.7cm).
Collection of Claes Oldenburg and
Coosje van Bruggen.

All the same, the idea of relying heavily on writing in so monumental a sculpture had to be undertaken with care. The first model was made in 1987 by taking a typically mundane object, an empty plastic bottle of Evian, ripping off the label and covering the surface with felt-pen scribbles. Having cut the bottle to reduce it to the right height, they then lodged it at an angle in a cardboard box filled with sandy granules of Pelliculite. The experiment taught them that the words would have to be large if they were to avoid the danger of becoming feebly ornamental. But the bottle's gleaming texture was still very evident. They then realised that, as well as dispensing with paper and ink, their sculpture must shed its links with plastic, glass or any other bottle-like substance apart from the material employed for the words themselves. While the cork remained paradoxically intact,[21] the rest of the bottle would be made solely and unequivocally of the writing it contained.

In this respect, the sculpture broke free from the images in early twentieth-century art which could be cited as art-historical precedents. Boccioni's 1912 bronze, *Development of a Bottle in Space*, possesses much of the dynamism which gives *Bottle of Notes* its whirling force. But while Boccioni charges his bottle with a sense of expansive Futurist motion, opening its forms outwards to engulf the surroundings, words play no part in its complex structure. The bottle images deployed in so many Cubist still-life paintings, drawings and collages seem more closely related to the Middlesbrough sculpture. For both Picasso and Braque relied heavily on the presence of verbal material between 1912 and 1914. At no time, however, did these fragments assume the dominance which writing enjoys in *Bottle of Notes*. Braque and Picasso ensured that words always remained one element among many in their Cubist work. Oldenburg and van Bruggen, by contrast, allowed the writing to become the paramount element in the sculpture, even if their decision to employ two sets of 'notes' means that the words are only decipherable after a considerable effort has been made to puzzle them out.

Why are these disparate passages conjoined, and where do they originate? The most visible of the quotations, from a distance at least, was found by van Bruggen in Cook's journals. He describes, with evident satisfaction, how 'we had every advantage we could desire in observing the whole of the passage of the Planet Venus over the Sun's disc'. Written in 1768, during the captain's first exploratory voyage which took him all the way from Plymouth to New Zealand, the sentence comes from an official log recording a man's professional fascination with studying an eclipse. Van Bruggen settled on this quotation 'because it was central to the act of exploration, which depended on the astronomers' accurate determination of longitude'.[22] But the phenomenon of eclipse itself lies at the heart of the sculpture.

At first, Cook's words – masculine, matter-of-fact, public prose starting with the pronoun 'we' – appear to obliterate the text on the interior. If viewers peer through them to the other side, though, his sentence is then eclipsed by the Venus-like

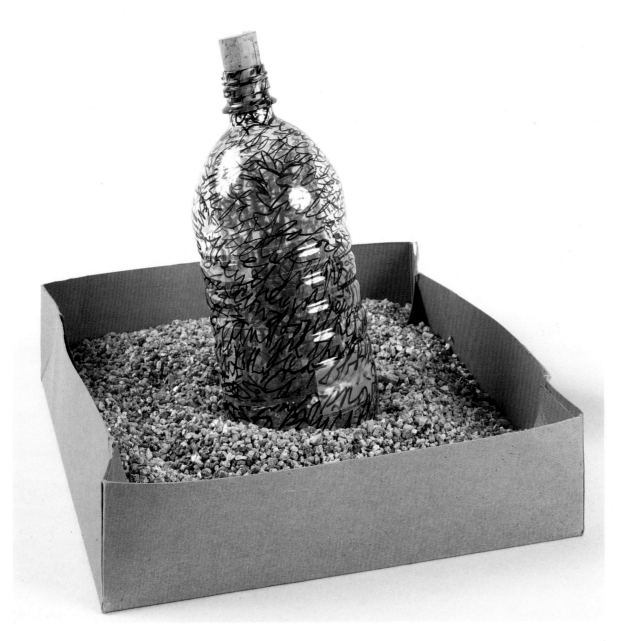

presence of the writing within. Taken from a group of short poems called 'Memos of a Gadfly', composed by van Bruggen in 1987 during a summer holiday in Montauk, Long Island, the words are lyrical, retrospective and celebrate an intimate experience rather than a public observation:

'I like to remember sea-gulls in full flight gliding over the ring of canals'.

Based on recollections of her childhood in Amsterdam, where the canals bear witness to Holland's seafaring prowess during the century before Cook's exploits, van Bruggen's sentence takes a quiet delight in the exhilarating freedom and resilience of birds observed from another coast of the sea bordering Middlesbrough.[23]

On a personal level, the two texts surely symbolise the relationship between Oldenburg and van Bruggen themselves. Originally, they planned three passages of writing: Cook's on the outside, and theirs within. But then, conscious no doubt of the dangers inherent in over-elaboration, they fused Oldenburg with Cook. The sculptor became identified with the explorer, and Oldenburg's angular handwriting is used to inscribe the words from the captain's log. Van Bruggen's more rounded script is employed for her interior text, and in this respect the two passages are clearly differentiated. Their positioning, however, implies an intimate reciprocity between them. Taking turns to 'eclipse' each other, male and female are nourished by their intertwining. Furthermore, the joint signature 'CoCos', in shining stainless steel on a plaque inside the sculpture, spells out the pleasure taken by both artists in the felicitous fact that the letters 'CO' are shared by Cook's surname, van Bruggen's christian name and Oldenburg's initials.[24]

While celebrating the unusual empathy which binds the artists in love and work alike, the two sets of 'notes' remain separate from each other. Painted colour helps to mark out their distinctive identities: off-white for the outside, blue for the words within. The rhythms set up by the writing are differentiated, too. Although Cook's sentence can be read from a distance by anyone patient enough to persist, Oldenburg's handwriting lends it a strong formal presence. Springing upwards from the ground, the words seem to be driven by the surge of the sea and the force of the wind. Their rippling progress around the sculpture encourages the viewer to keep on the move. For *Bottle of Notes* cannot be properly appraised from a fixed position: as sculpture in the round always does, it demands and richly repays circumambulation.

But unlike most sculpture, it invites penetration as well. The holes puncturing *Bottle of Notes* at every turn tempt us to step inside. And once there, the structure assumed by van Bruggen's words takes on a sharply individual character. Although the letters are more roughly cut than the smoothed-out exterior, they have an astonishing vivacity. Spiralling wildly above our heads, as if in tribute to the 'immense concentric circles' imprisoning the vessel in Poe's story, the words spin up with dizzying force.

Opposite:
Study for the Spiral of Coosje's Script in the 'Bottle of Notes', *1987 (detail). Pencil on paper. 11 x 8¹/₂ ins (28 x 21.6cm) on sheet 30 x 40 ins (76.2 x 101.6cm). Collection of Claes Oldenburg and Coosje van Bruggen.*

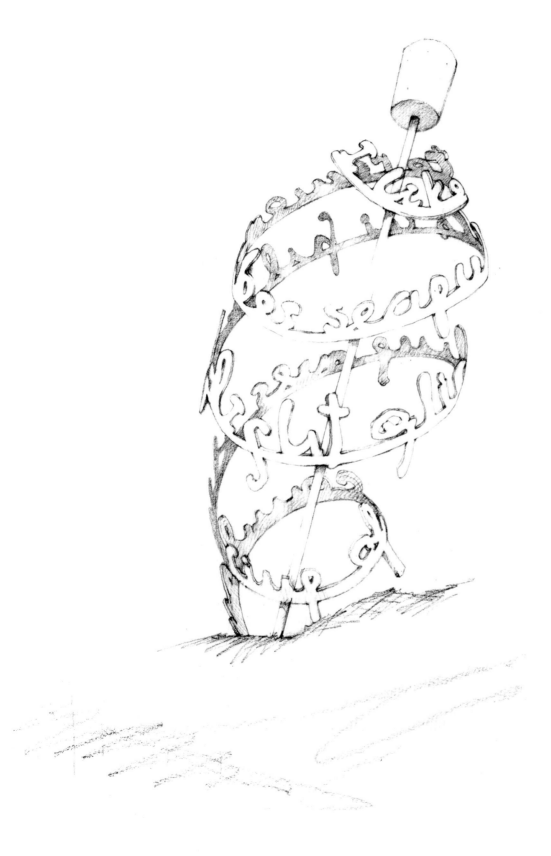

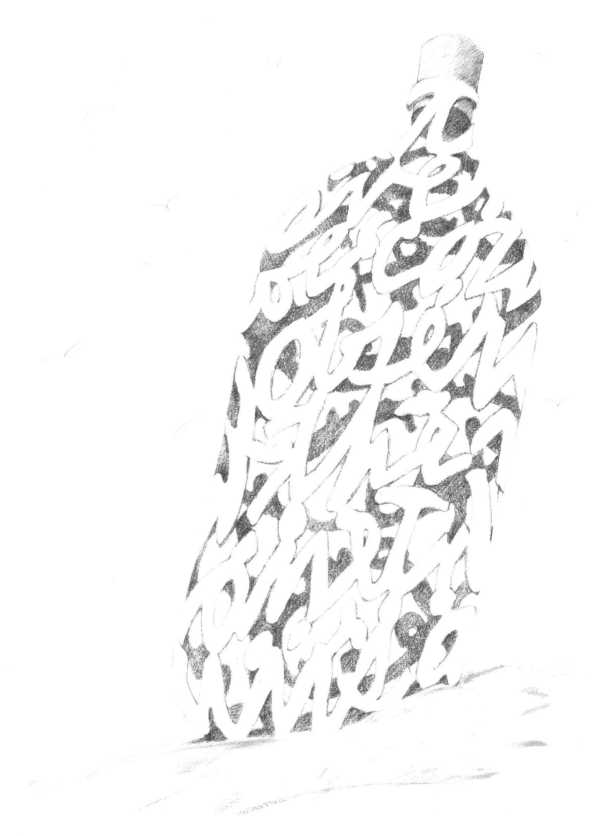

The final effect, however, is exuberant rather than in any way associable with the gothic terror of 'Ms. Found in a Bottle'. The whirling lines are far more energetic than the stately circles ascending Duchamp's ready-made iron *Bottle Rack*, which he purchased in a Paris department store in 1914. Instead, they have a whiplash energy reminiscent of Tatlin's *Monument to the Third International*, a soaring model which encapsulates the utopian dynamism of the Russian avant-garde immediately after the Revolution. But the *élan* conveyed by the words inside *Bottle of Notes* makes them seem lighter and more balletic than the text on the outside, and in this sense they remain true to the spirit of van Bruggen's poem. Standing inside the sculpture is like finding ourselves at the foot of a stairway spinning up deliriously to the sky, with an onrushing momentum only brought to an end by the cork's substantial presence at the apex.

This adrenalin-inducing vertical thrust is given further, unexpected tension by the sculpture's tilting position. Leaning at an angle of seventeen and a half degrees, *Bottle of Notes* looks almost as precarious as the Pisan landmark which helped to inspire its tipsiness. When the first model was made with the Evian bottle, it was placed next to a porcelain cheese-dispenser in the form of the leaning tower, a souvenir acquired several years earlier. Much of the Tuscan building's popularity derives from the observer's awareness that it is in peril. A similar *frisson* is aroused by the tilt in the Middlesbrough sculpture. It accords with Oldenburg's declaration, in his feisty 1961 credo, that 'I am for art falling, splashing',[25] and the angle at which *Bottle of Notes* is positioned might well suggest that it has been washed ashore and beached there accidentally by a receding wave. The proximity of the newly created lake and rocky cascade in the area inhabited by the sculpture reinforces this notion, as well as providing a reminder that the sea itself is not far from the centre of the town.

Oldenburg and van Bruggen believe that their sculpture should appear 'as if stuck in sand'.[26] Although safely secured in a bed of bark, *Bottle of Notes* does look far more unstable than most public sculpture. Even more than his previous works like the *Tilting Neon Cocktail,* or the *Toppling Ladder with Spilling Paint* in Los Angeles, it challenges the convention of monumental immutability – just as it subverts the whole tradition of sculptural solidity by peppering the surface with holes and encouraging the viewer to clamber inside. This is an object which might once have bobbed in water as immense as the ocean surrounding Cook himself. One of Oldenburg's preliminary watercolours shows the bottle floating in just such a context, encircled by an archipelago of island-like forms which turn out to represent earlier sculptural projects like the three-way plug, the toothbrush, the broken pencil and the burnt match. Inscribed with their names in reverse, a device which generates words as exclamatory as 'gulp-yaw-eerht', the island images confirm the idea of the artist as an explorer, forever fashioning an alternative, frankly outlandish world from the most quotidian of starting-points.

Opposite:
Study for the Bottle of Notes, *1987.*
Pencil and coloured pencil on paper.
30 x 25 1/2 ins (76.2 x 65cm).
Middlesbrough Art Gallery,
Middlesbrough.

Below:
Toppling Ladder with Spilling
Paint, Fabrication Model, *1986.*
Steel painted with enamel.
18 3/4 x 12 x 12 ins
(46.7 x 30.5 x 30.5cm).
Collection of Claes Oldenburg and
Coosje van Bruggen.

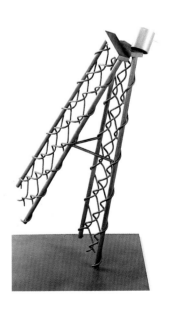

By its very nature, a bottle with a message should seem a frail, even breakable object. But if the Middlesbrough monument is compared with Alexander Calder's 1938 *Tower*, another tilting, see-through sculpture by a New York-based artist, its fundamental toughness becomes clear. Calder's delicate metal and wood construction looks flimsy beside Oldenburg and van Bruggen's behemoth. *Bottle of Notes* has been built to last, at a cost of £130,000, and Middlesbrough council is set on maintaining the sculpture's clean-cut finish as zealously as possible.

Although the town's ratepayers have contributed only £5,000 towards the work, it could have been rejected at an early stage in the negotiations by council members who questioned the appropriateness of the chosen image. Its connections with Cook are by no means obvious at first glance, and the idea of installing a king-size, slanting, word-splattered bottle full of holes in the newly regenerated town centre might well have filled them with misgivings. To Middlesbrough's everlasting credit, though, support for the project remained firm. Some opponents maintained that the bottle was an insulting symbol of alcoholism in the region, or that the commission should have been given to a British artist. The leader of the Cleveland County Council's Conservative opposition, which tried to block the town's modest financial contribution to the sculpture, predictably denounced it as 'a blot on our landscape'.[27] But the majority of council members were enlightened enough to spurn such a clichéd response, and realise that Oldenburg and van Bruggen would provide them with an enormously stimulating landmark. After all, Cook's achievements are already honoured in the centre of the town by a large, slowly revolving replica of the *Endeavour*, suspended from the top-lit ceiling of Middlesbrough's main shopping centre near the site now inhabited by *Bottle of Notes*. No imaginative artist should be expected to vie with such a literal image, and the council must have recognised that the bottle proposal possessed manifold connections with the area.

If the 'stranded' appearance of the sculpture suggests that it has arrived at its destination by chance, and might one day be thrown out to sea again, its relationship with the location is in fact subtly considered. An early notebook contains a photograph of the beach, with a drawing of *Bottle of Notes* lodged in a position near the water's edge. It reminds us that Oldenburg also announced, in his 1961 manifesto, that 'I am for art that comes in a can or washes up on the shore'.[28] In reality, however, there was never any viable alternative to the site in the Central Gardens. The area was planned before the commissioning of the sculpture, so the artists could not work with the landscape architects on its design. But Oldenburg and van Bruggen were allowed to choose a site anywhere in the area. They selected a setting above and at the edge of the Gardens, in order to give the sculpture maximum visibility and relate it to the nearby architecture.

Apart from its links with the lake, and by extension the sea bordering Middlesbrough, *Bottle of Notes* therefore responds to the presence of the municipal

Opposite, (top):
Gate in Middlesbrough.

(middle):
Middlesbrough's Transporter
Bridge.

(bottom):
Notebook Page – Proposal for a
Gearstick to Replace the Nelson
Column, Trafalgar Square, London,
1966 (detail).
Felt pen and watercolour on postcard
mounted on paper.
5¹/₄ x 3¹/₂ ins (13.2 x 8.8cm) on
sheet 11 x 8¹/₂ ins (28 x 21.6cm).
Collection of Claes Oldenburg and
Coosje van Bruggen.

offices nearby. It tilts away from the water and towards the buildings. And its overt homage to the leaning Tower of Pisa means that its presence seems almost as much architectural as it does sculptural. Another photograph in the artists' notebook focuses on a neighbouring gate whose shape echoes the sculpture, and they also wanted to play off *Bottle of Notes* against what they describe as the 'bottle-like'[29] church at the east end of the promenade.

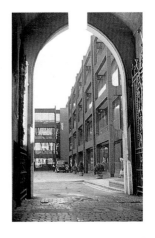

Nor do the sculpture's links with Middlesbrough end there. The decision to concentrate principally on Cook should not obscure the fact that *Bottle of Notes* contains references to the present-day identity of the town. 'On first encounter', the artists recall, 'Middlesbrough seemed devoted entirely to industry, surrounded by factories, covered in smoke and industrial odours. A cloud hung over it as one approached from the North.'[30] Focusing on Cook may seem like an attempt to escape from this rebarbative reality, but on a formal level the sculpture chimes with some of the shapes assumed by the chemical plants dominating so much of the town. Moreover, the open structure of *Bottle of Notes* pays an implicit tribute to the magnificent Transporter Bridge, whose tensile strength encouraged them to think in terms of a sculpture defined essentially by line.

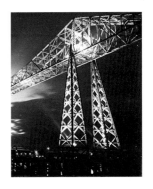

Drawn in space, with flamboyant and yet rigorously refined panache, the completed sculpture attests as well to the traditional fabrication skills of the region. The project's success in attracting funds depended to a significant extent on the recognition that local trainee labour would help to make *Bottle of Notes*. At a time of accelerating unemployment and industrial recession, this involvement provided a welcome symbol of regeneration. Moreover, British Steel agreed to assist the venture by donating all eight tons of the mild steel required. So although the sculpture concentrates thematically on the maritime past, its formal structure owes a great deal to Middlesbrough's industrial present.

Not that *Bottle of Notes* proclaims any of these references in an overt or programmatic way. It is a surprising, even mysterious image, eschewing the ponderous dignity associated with civic monuments like Nelson's Column, which Oldenburg proposed replacing in 1966 with a moveable gearstick as a salute to all the cars negotiating their way round Trafalgar Square. Compared with such an irreverent work, or his related proposal to replace Eros in Piccadilly Circus with a cluster of jumbo lipsticks, the Middlesbrough monument may seem almost enigmatic.[31] But Oldenburg and van Bruggen liken it to 'a trace that people can pick up and follow on their own. The *Bottle of Notes* is essentially about itself, but it takes some of the ingredients of the surroundings, like Capt. Cook, into it.' As for the writing, they insist that 'both texts are deliberately open as to interpretation'.[32]

The artists are aware that Middlesbrough is a living town, where change can be expected. The sculpture's surroundings may alter as dramatically in the future as they have done since Oldenburg initially surveyed the site in 1986. But he accepts the

inevitability of change as readily as he welcomes the variety of meanings which local people will surely attach to the monument. It is bound to elicit a strong reaction, whether positive or negative, from everyone who comes across it. And the modest size of Middlesbrough may help to ensure that *Bottle of Notes* is more vigorously debated there than it might be in a large, impersonal metropolis. When Oldenburg and van Bruggen first visited the site, they realised that its surroundings 'had less identity than most towns we had visited in England'. But they were not deterred by the seeming anonymity of the place. In a smaller town, they reasoned, their sculpture had 'more of a chance of functioning in a community as an identification of a neighbourhood, which is what we desire our Large-Scale Projects to do'.[33]

Even as the people of Middlesbrough sort out their responses to *Bottle of Notes*, it serves a far wider purpose, too. For the town can be proud of the fact that such a distinguished work will quickly acquire an international reputation, and that nobody else in Britain has been adventurous enough to commission a sculpture from Oldenburg and van Bruggen before. *Bottle of Notes* amounts to a spectacular coup, showing how Middlesbrough has set a challenging new standard to the rest of the country in its willingness to place this provocative, multi-layered, enlivening and, in the end, stubbornly optimistic image at the very heart of urban life.

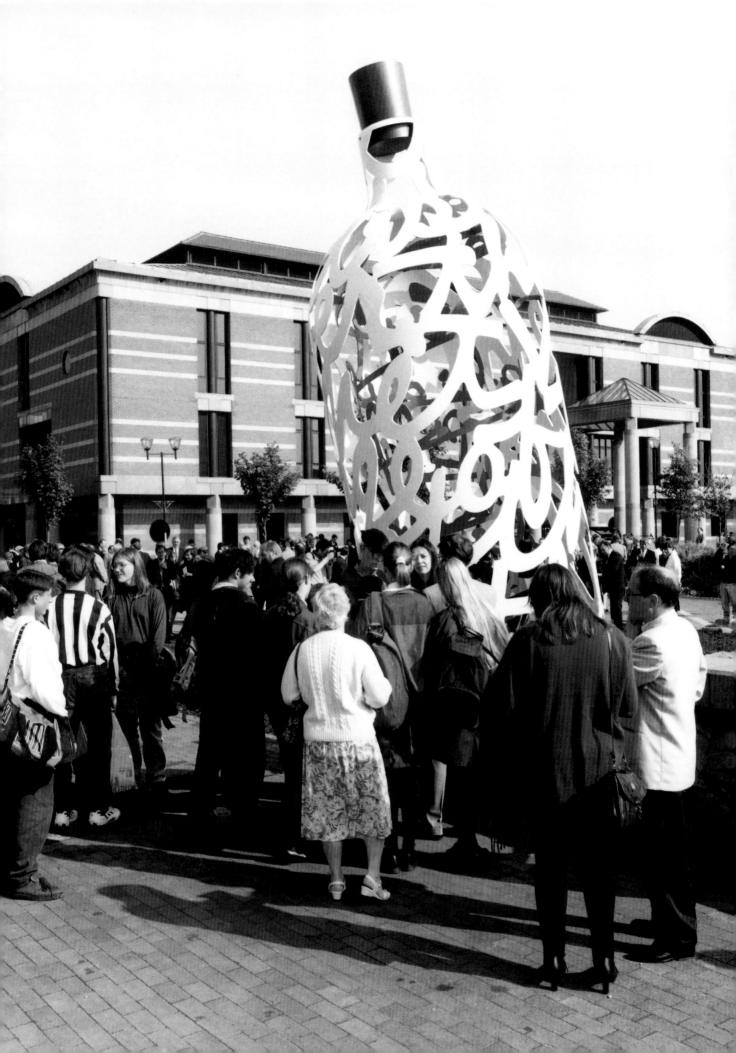

Fabrication of the *Bottle of Notes* sculpture was a monumental task and not one for the faint-hearted. In this respect, the project no doubt had much in common with the Ironmasters and Bridgebuilders, with which the name of Middlesbrough is proudly synonymous throughout the world.

The rapid growth of Middlesbrough as a producer of iron and steel has since the 1950s been matched by a rapid decline in the numbers employed in the industry. Use of these redundant skills and an opportunity to demonstrate that the metal-making prowess of the area was alive and well was one of the motives for embarking upon the project. Middlesbrough Council had, prior to the *Bottle of Notes* commission, established a partnership with AMARC, formerly the training arm of British Ship-builders, with various operations throughout the country including Middlesbrough and Hebburn. AMARC provided the unemployed with training in metal fabrication and other skills.

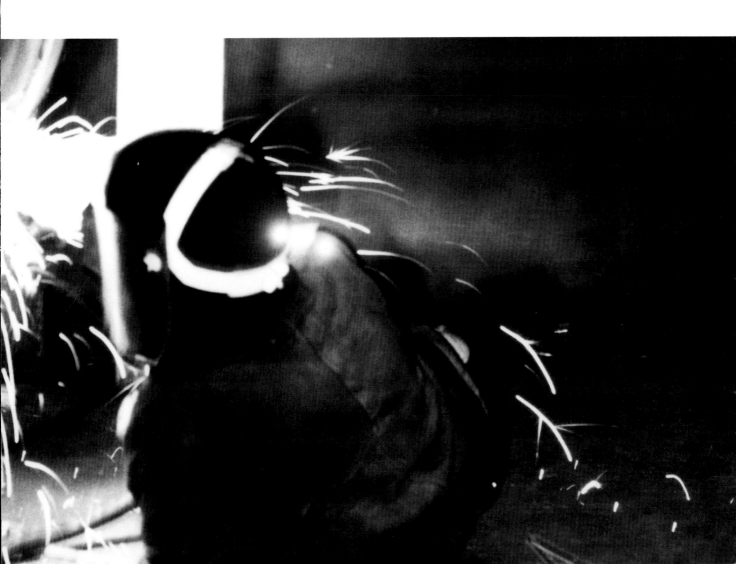

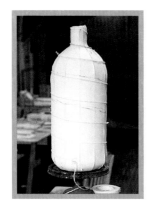 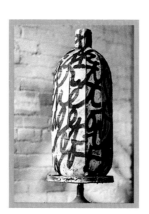

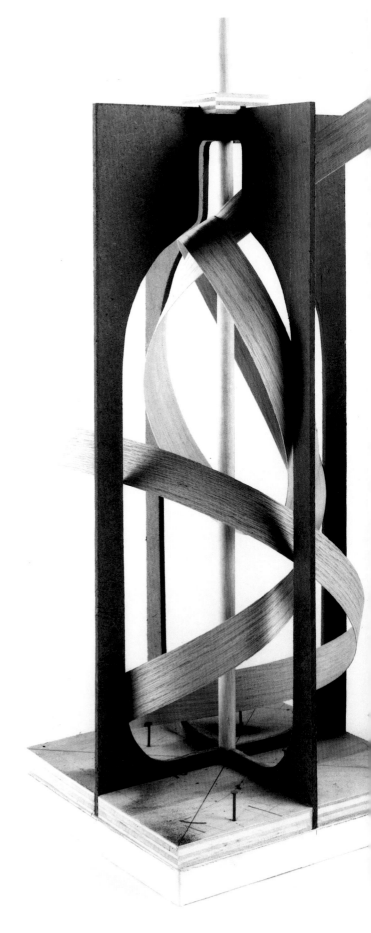

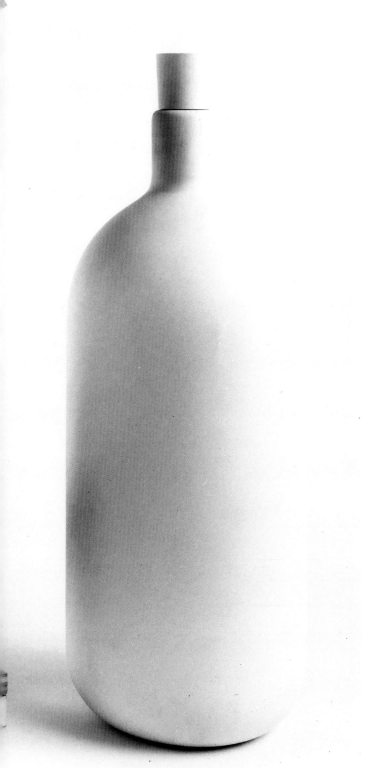

Below and left:
Bottle of Notes Maquettes,
1988.

Centre and below:
23^1/$_4$ x 9^1/$_{16}$ ins
(59 x 23cm) height and diameter.
Given to Leeds City Art Gallery by The
Henry Moore Foundation, Leeds,
England, 1992.

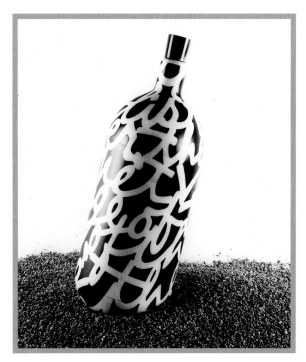

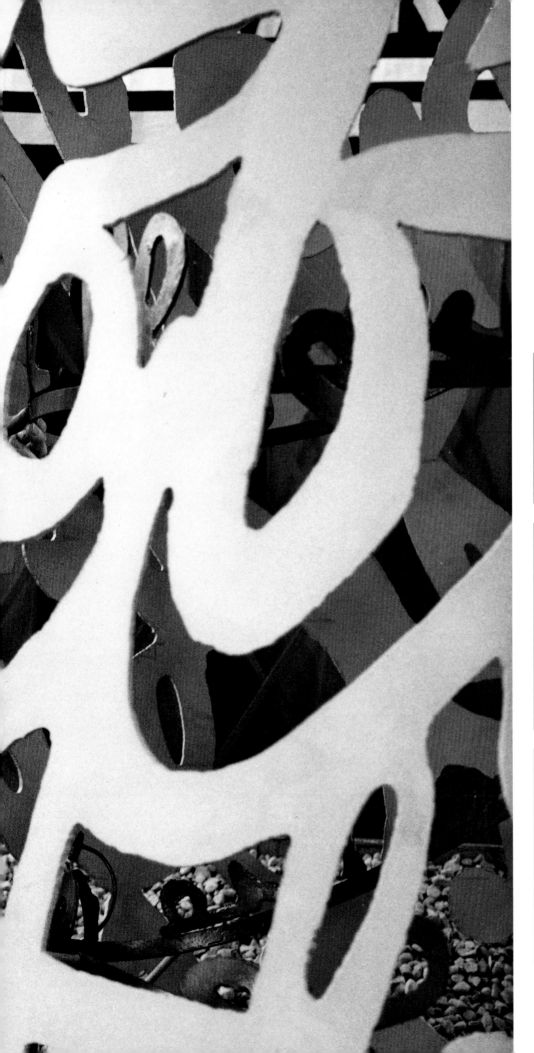

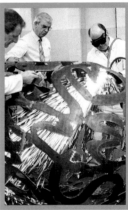

Changes of Scale

Translating Oldenburg's two-dimensional images to a three-dimensional form was the start of the fabrication process. Plaster and wooden maquettes were provided by the artist and under the supervision of Les Hooper, a freelance commission's agent, who was later to be employed by AMARC at Sculpture North in Hebburn, fabrication work on a twelve-foot high preliminary fabrication model (a third of the size of the finished version) commenced at Middlesbrough in June 1989. The preliminary model was fabricated from six-millimetre mild steel plate supplied by British Steel from Scunthorpe, who also supplied the twenty-millimetre steel plate for the full-scale version.

A steel cylinder was made, with rolled steel segments welded together. The bottom and top hemispheres of the bottle were spun into a dome shape by Metal Spinners, Newcastle. Fabrication of the upper section of the *Bottle*, from the top shoulders to the neck, proved to be rather difficult, as was the case with the full-scale version. Having fabricated a steel bottle, the next problem was how to transfer the inner and outer text accurately from Oldenburg's drawings.

Les Hooper painstakingly chalked out the letter outlines, using a grid pattern from the maquette. The areas between the letters were then cut out using a plasma arc cutter. The inner spiral was constructed from letters individually cut out from van Bruggen's original text using a computerised profile burning machine, which were then welded to a steel bar to produce the inner spiral.

The fabrication model, completed in May 1990, highlighted the technical difficulties, in particular the accurate large-scale translation of the script, and demonstrated the need for specialist labour to achieve a high quality of finish. Oldenburg and van Bruggen visited AMARC and discussions took place on the problems of fabrication. It was obvious that in order to achieve the quality of finish required, other methods and expertise would be needed. The other major problem was that the full-size sculpture would be too big for the fabrication sheds at Middlesbrough and therefore it was reluctantly agreed that work be transferred to the AMARC facility at Hebburn which Oldenburg had previously visited. While the fabrication model resolved some of the difficulties as to how the large-scale sculpture could be realised, it was inevitable that fabrication of the full-scale version would create other problems. Oldenburg and van Bruggen acknowledged the difficulties and in order to help overcome the technical obstacles, they commissioned Don Lippincott, an American fabricator, to build a third-scale model in aluminium, with the help of an experienced metal-cutter borrowed from the Rhode Island factory where Oldenburg's and van Bruggen's *Spoonbridge and Cherry* of 1988 had been fabricated. This model was completed for an exhibition at Leo Castelli Gallery in New York in November 1990 after which it became part of the exhibition of 'American Pop Art' at the Royal Academy in London in September 1991.

Paul Crozier, of Sculpture North, was able to view the aluminium model and use this to develop specific measurements as a standard for the sculpture's finished appearance.

Opposite:
Bottle of Notes (Model), *1989-90.*
Aluminium and expanded polystyrene, painted with latex.
8ft 11ins x 4ft 1ins x 3ft 3ins
(2.72 x 1.24 x 0.99m).
IVAM, Instituto Valenciano de Arte Moderno, Generalitat Valenciana, Valencia, Spain.

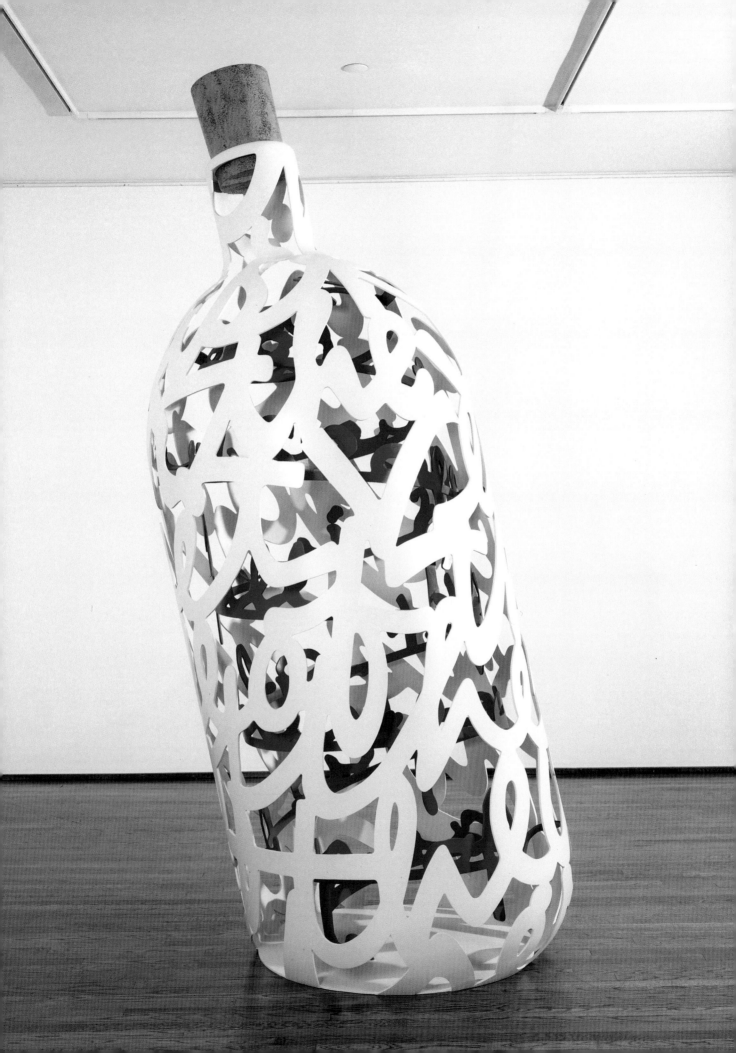

The Full-Scale Object

The top hemisphere of the full-scale sculpture was too big to spin and was cast in individual segments which were then joined together. As with the original fabrication model, the tight compound curves of the bottle neck in twenty-millimetre steel proved difficult. These difficulties were overcome by a combination of heatline bending techniques, suitable dished cut-outs from the base, and special castings (from masters produced by Les Hooper).

Following discussions with Oldenburg and van Bruggen on the difficulties of fabrication, Les Hooper and Paul Crozier resolved the problems of enlarging the script. They devised a method of computerised digital enlargements to an 'as-build' size, to be transferred to laser-cut hardboard. This in turn would be nailed (Kango nails) to the full-sized steel blank. After correction to resolve the discrepancies that digitising produces, this would act as a guide runner for the burning-out on all but the tightest curved surfaces. In this way the cutter was guided physically by the artist's hand as opposed to the operator's eye.

Even so, the full fret, the inner spiral, went through some fairly substantial modifications after the artists saw the full-sized results for the first time. Once the giant spiral was attached to the steel bottle, the final image started to emerge. Throughout this time, interest in the *Bottle* was considerable and a number of individuals and organisations, including Lord Palumbo, visited Hebburn to review progress.

During this time, Sculpture North and AMARC were taken over by the Francis Group and as a consequence of this, due to a cost-cutting exercise in April 1991, Les Hooper was replaced by Paul Crozier as Project Director. Progress was slow and the costs of the project increased as further technical problems arose. The financial problems of the Francis Group came to a head late in 1992 when it went into liquidation. Sculpture North was tangled up in the ensuing difficulties and was unable to trade, bringing the project to a standstill. A further complication was the discovery of asbestos at the Hebburn plant which meant not only that no further work could be undertaken but also that the sculpture could not be moved elsewhere. These problems could have been seen as insurmountable but such was the interest and commitment to the project by the project officers, that they persisted in their optimism that the problems could be resolved.

After a period of inactivity, Les Hooper resurrected the fabrication with Bob Lisle, who had bought up the ex-AMARC / Francis plant at Hebburn. Meanwhile, the asbestos problems had been resolved by South Tyneside Council. Lisle's new firm, Hawthorn Leslie Marine Fabrication Ltd, recommenced work in August 1992 and entered into a new contract with Middlesbrough Council. Under the supervision of Les Hooper and Charlie Alcock, work progressed rapidly, with all of the lettering cut out by a skilled team comprised of the following:

Charlie Alcock	*Workshop Manager*	*All staff HLMF*
John Lindsay	*Plater (responsible for assembly and finishing)*	*ex-AMARC*
Tommy Kidd	*Welder*	
Brian White	*Burner*	
Alan Bell	*Boilermaker (responsible for all rollings at Hebburn) ex-AMARC*	

The top of the bottle was then fixed to the main body, which Oldenburg viewed in December 1992, after which work began on constructing the base.

The inner spiral was cut out from solid plate and joined together. A small hitch had been that the spiral was rolled the wrong way, which meant it read from the bottom up. Despite an offer to remake this element of the work the artists decided in the event that this was not a problem.

In December 1992, Oldenburg made a further visit to Middlesbrough to discuss the siting. The initial suggestion for the site would have involved removing the top pond which formed part of the Central Gardens lake complex. So it was agreed that a small terrace would be provided with the *Bottle* set in it in a bark floor. This solution was sympathetic to the sculpture and to the concept of it being washed up on a beach, while also providing an impact-absorbing surface.

In March 1993, following further inspections of the sculpture by Oldenburg and van Bruggen, the completely cut bottle and inner script were sandblasted and painted grey. The following day a last visit was made to Middlesbrough to finalise details of the installation.

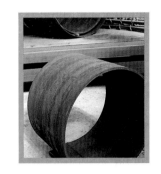
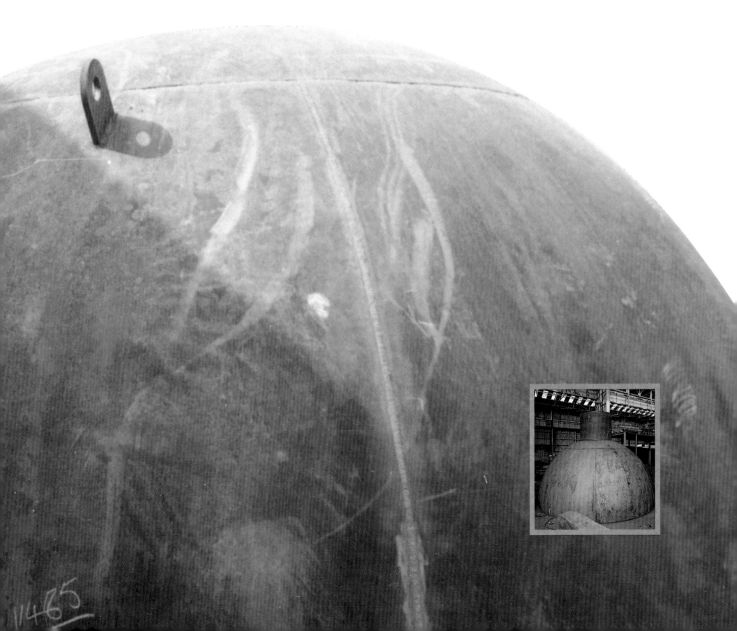

114 85

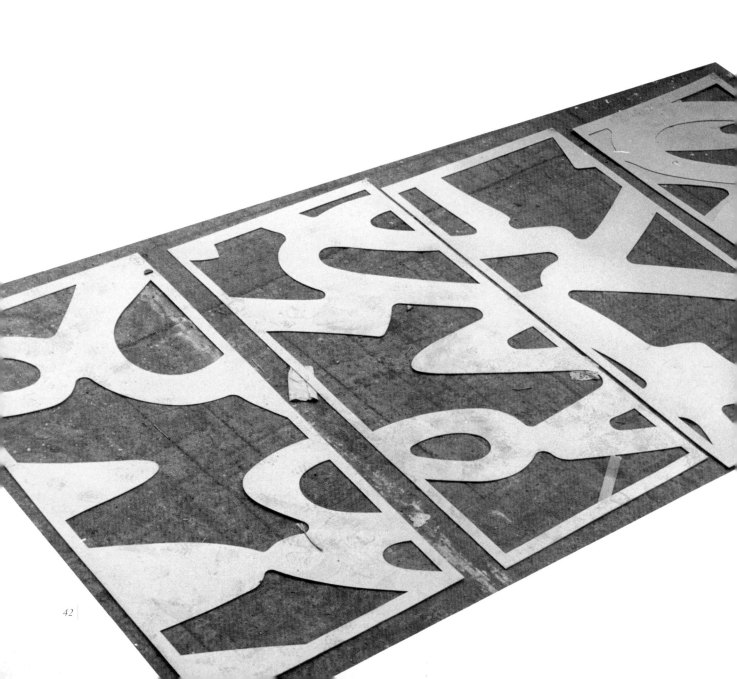

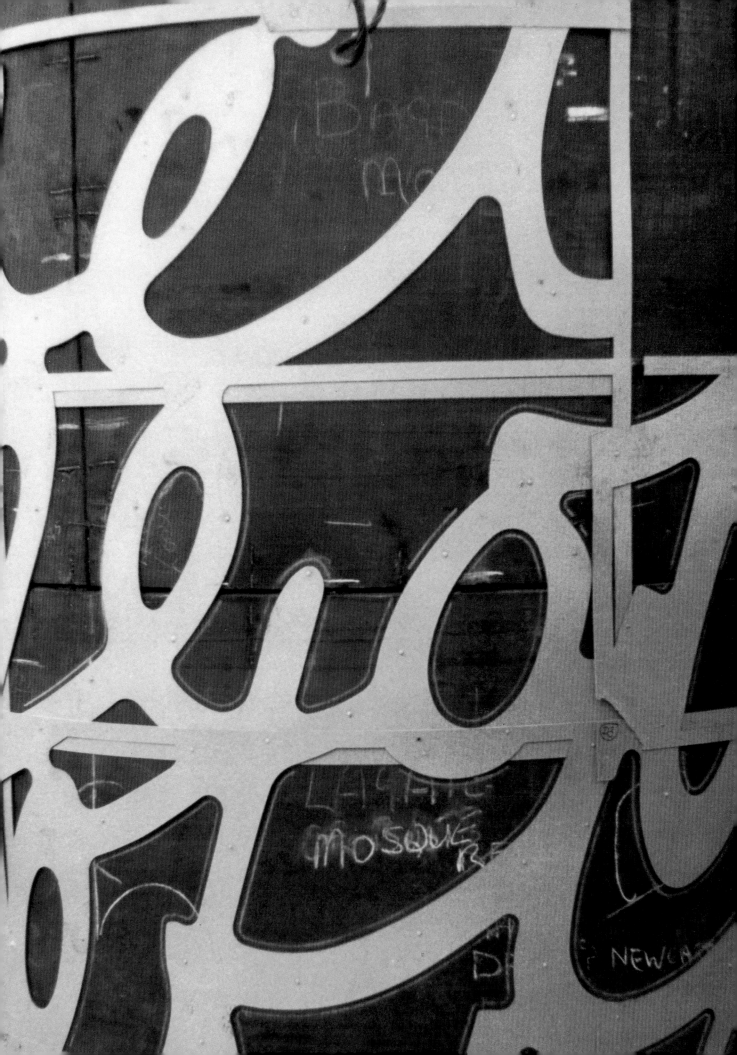

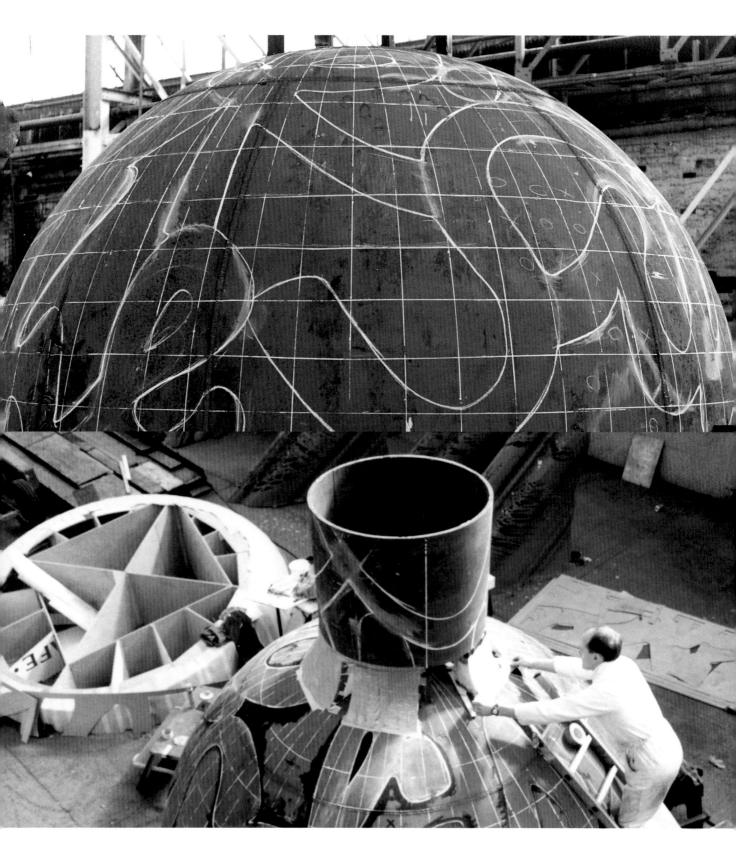

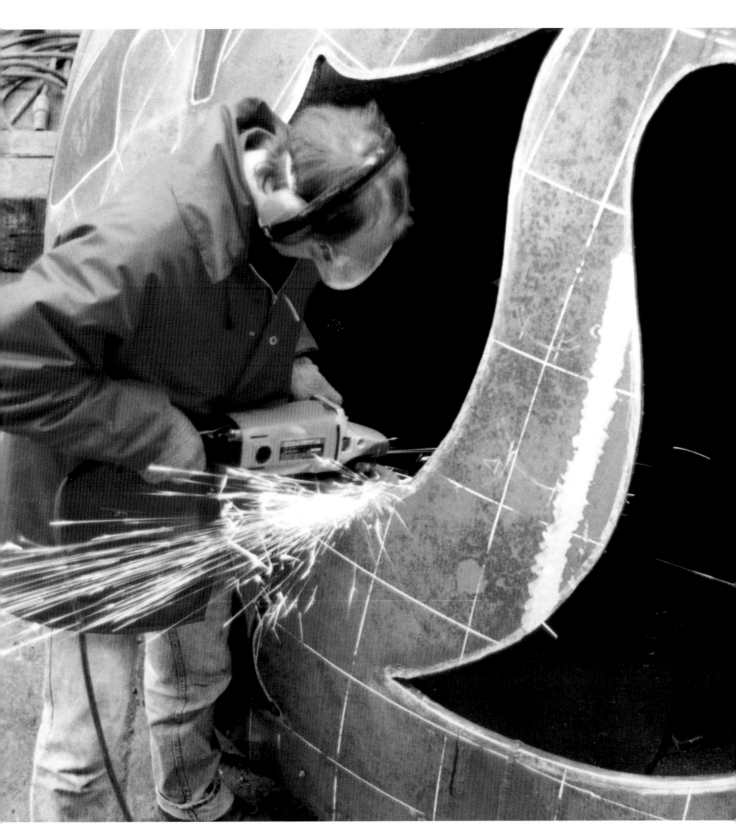

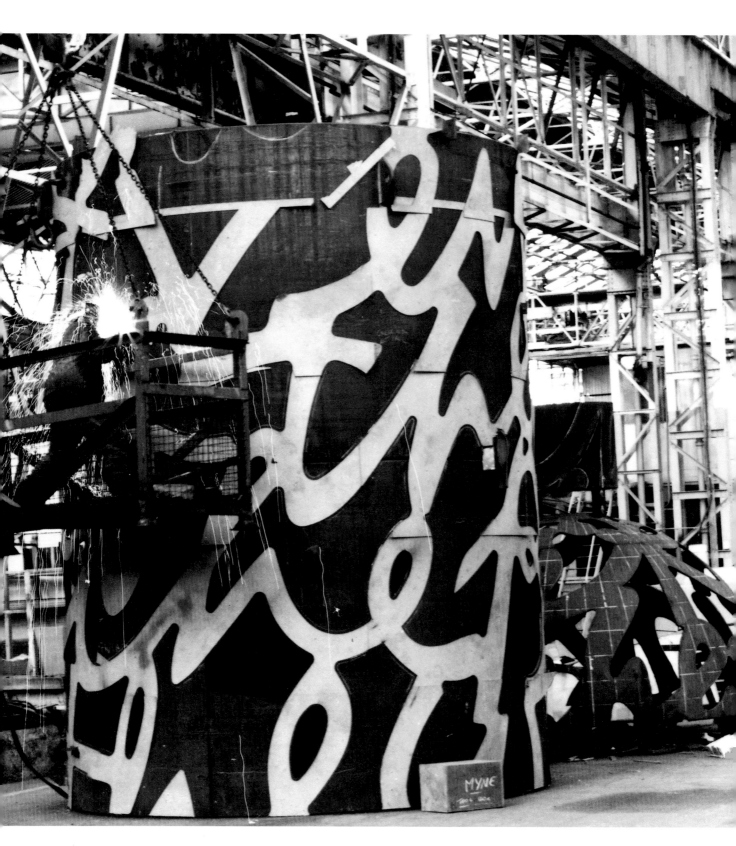

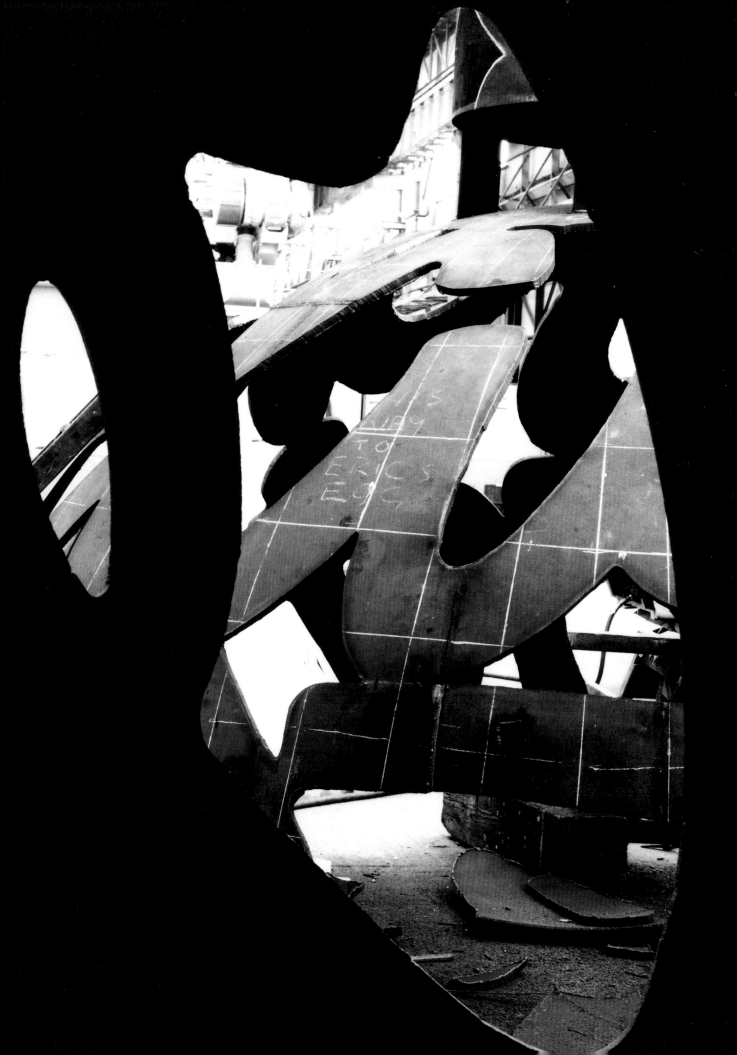

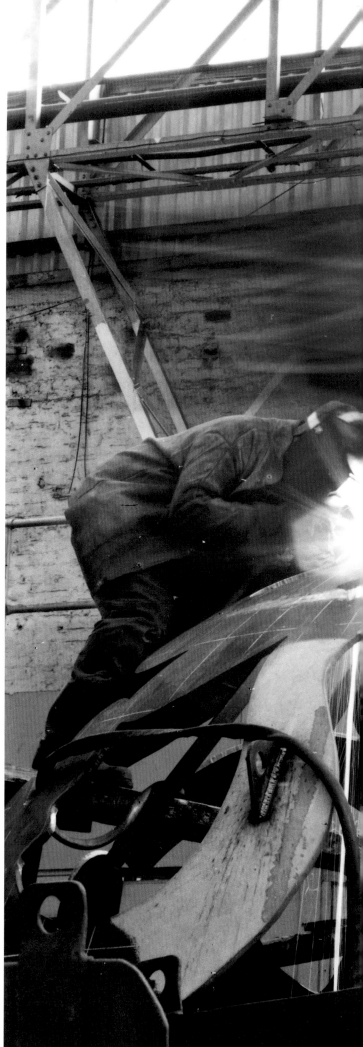

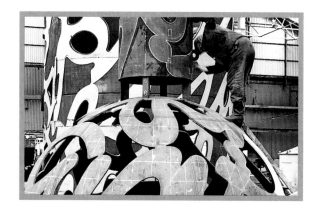

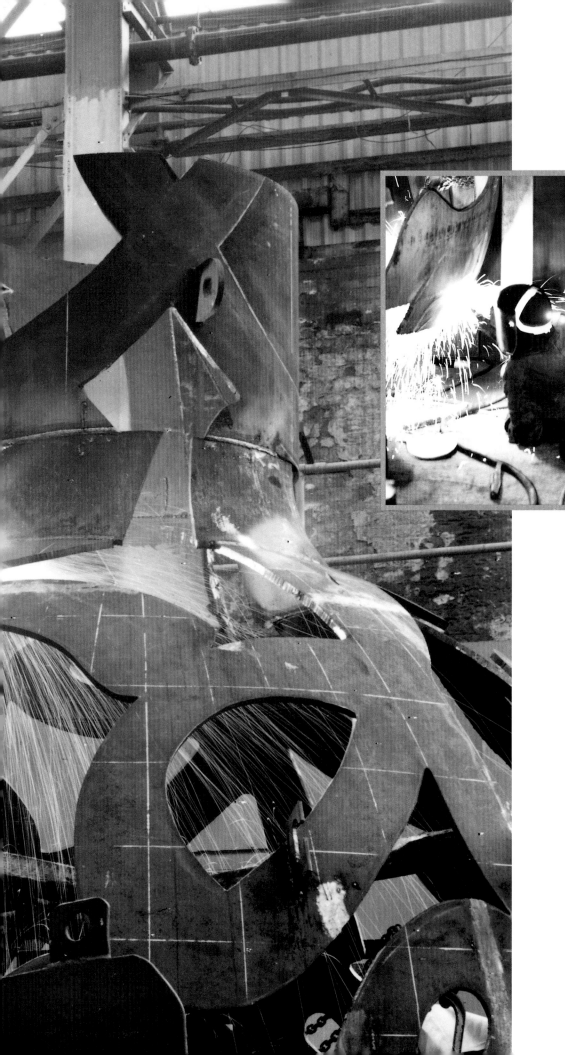

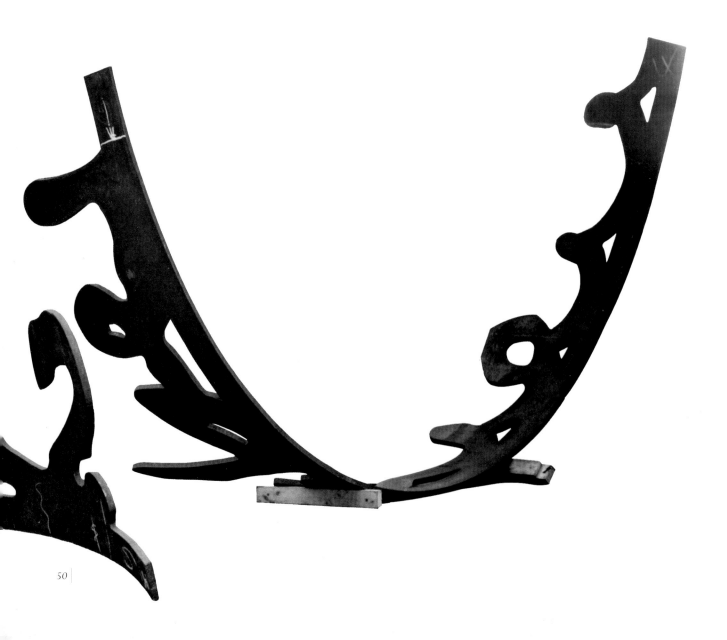

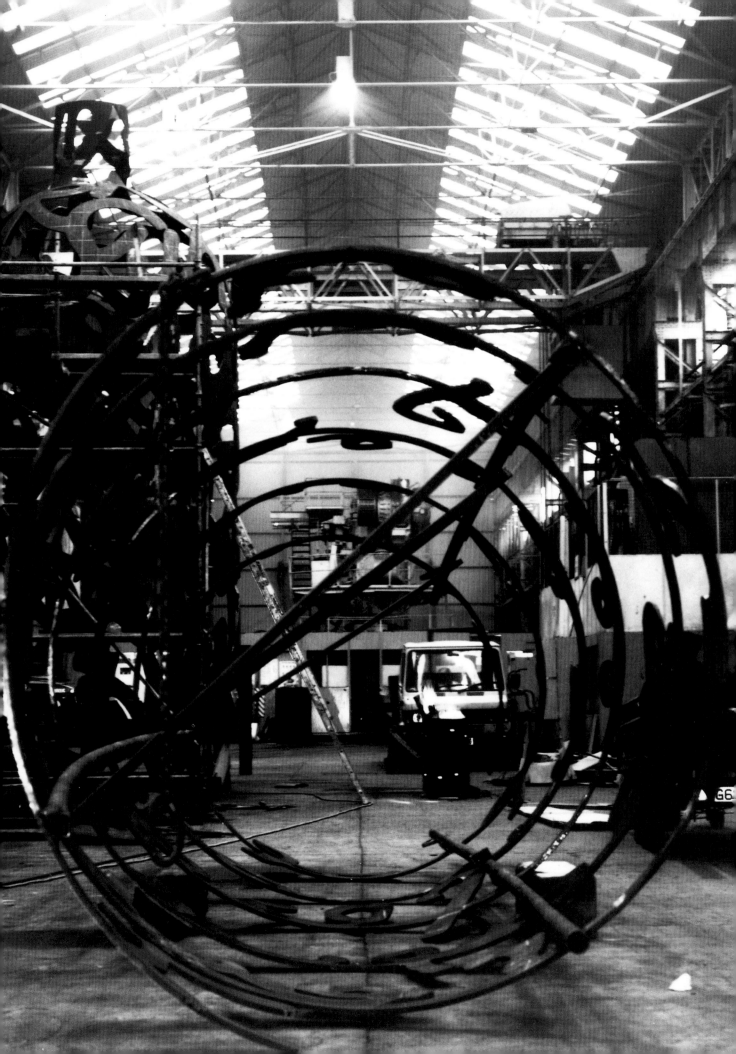

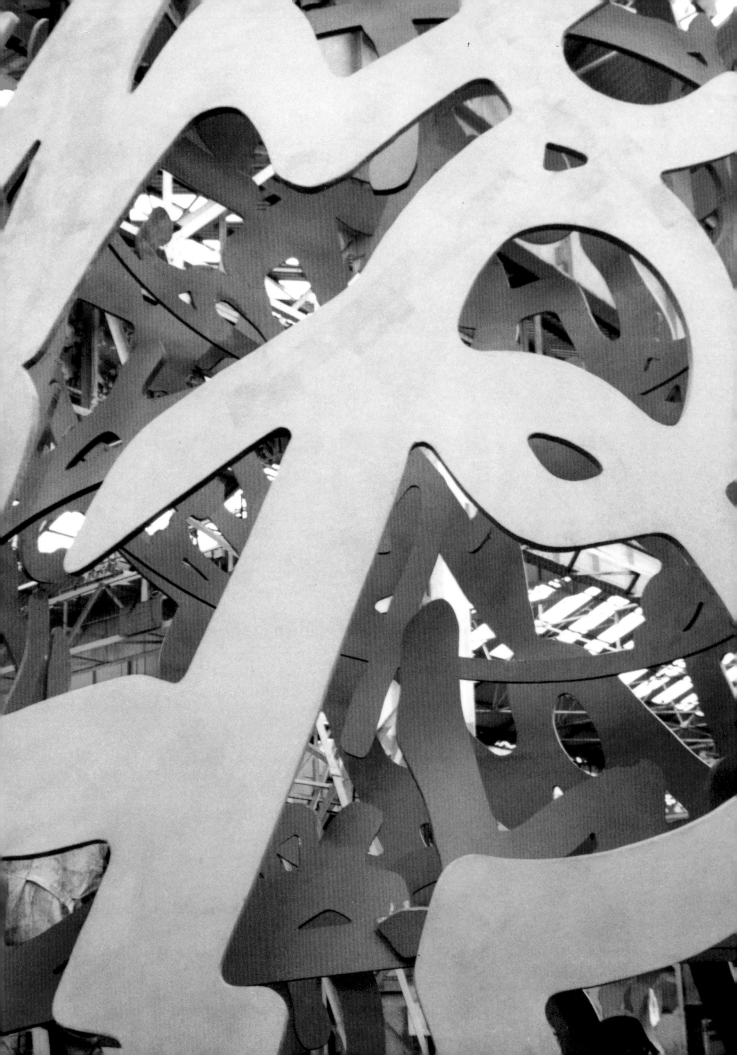

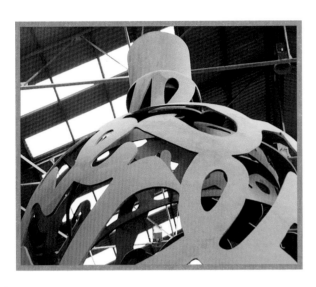

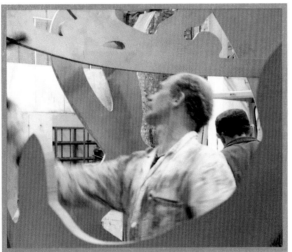

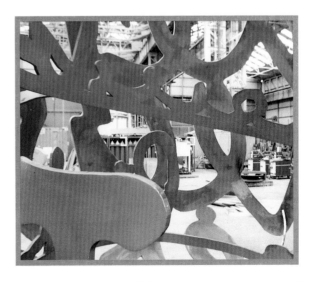

Journey's End

The voyage of the *Bottle of Notes* ended on 10 September 1993 when it was transported from Hebburn to Central Gardens in Middlesbrough. Not surprisingly, the media highlighted that an unusual load would be travelling along the A19 and it was with some surprise for those waiting eagerly on site that the load navigated the journey in such a short time, perhaps mindful of its links with Captain Cook's exploits. It had been hoped to transport Middlesbrough's new landmark to its final resting place via Middlesbrough's other famous landmark, the Transporter Bridge. However, the *Bottle* and transporter combined weighed more than the safe limits for the bridge, and the risk of two 'landmarks' falling into the Tees was too frightening to countenance.

Once arrived at its destination, two cranes were required to lift and manoeuvre the sculpture, all under the watchful eye of Charlie Alcock and his team. The sculpture was lowered into position and bolt holes drilled. Once the bolts were anchored the sculpture was lowered onto them first time, without any problems. None of those involved seemed to mind the atrocious weather conditions. The next few days were spent finishing off the painting work ready for the unveiling on the 24th. The *Bottle of Notes* had arrived.

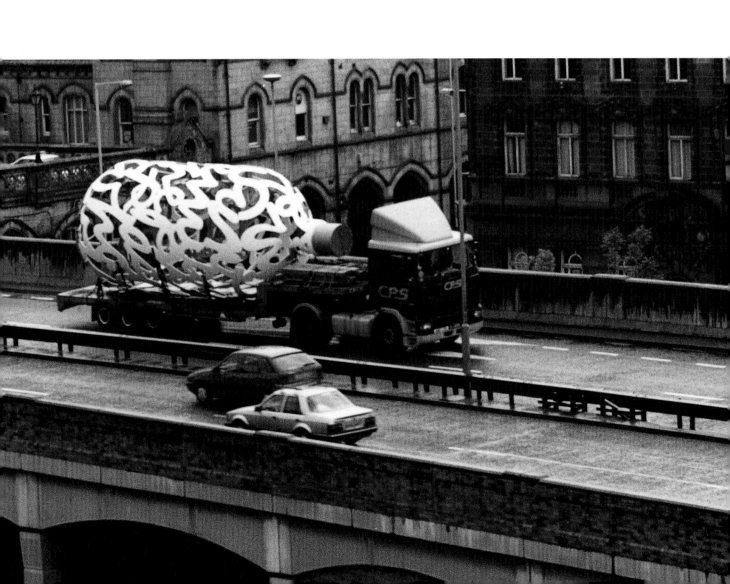

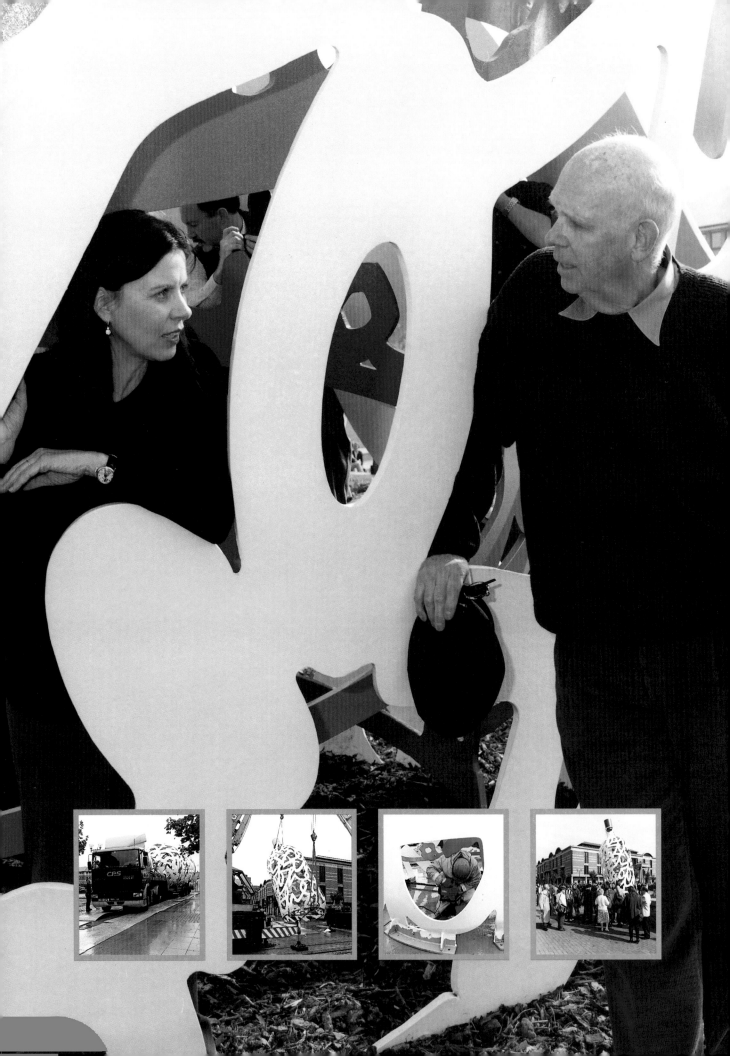

Claes Oldenburg / Coosje van Bruggen
Selected Biography
David Platzker

Claes Oldenburg

Claes Oldenburg was born in Stockholm, Sweden, January 28, 1929. After living in New York City; Rye, New York; and Oslo, Norway, his family settled in Chicago in 1936. Oldenburg attended Yale University 1946-50, and then returned to Chicago where he worked as an apprentice reporter at the City News Bureau and studied at the Art Institute of Chicago. He became an American citizen in December 1953. In 1956 he moved to New York City, where he has lived ever since, except for travels to Europe and Japan and a year-and-a-half in Deventer, the Netherlands. Oldenburg is married to Coosje van Bruggen, with whom he has worked on large-scale public projects and performances since 1976.

Coosje van Bruggen

Coosje van Bruggen, born in Groningen, The Netherlands, in 1942, received a Doctorandus degree in art history from the University of Groningen. She served as a member of the curatorial staff of the Stedelijk Museum in Amsterdam from 1967 to 1970 and co-edited the catalogue of the *Sonsbeek '71* exhibition in Arnhem. From 1971 to 1976 she taught at the Academy of Fine Arts in Enschede. In 1982, she was a member of the selection committee for *Documenta 7* in Kassel, Germany. She conceived the characters and co-authored the script for *Il Corso del Coltello,* a performance by Claes Oldenburg, van Bruggen, and Frank O. Gehry in Venice, Italy, in September 1986. With Dr Dieter Koepplin, she co-curated the exhibition *Bruce Nauman: Drawings 1965-1966* for the Museum für Gegenwartskunst, Basel, 1986. Van Bruggen is the author of *Claes Oldenburg: Mouse Museum / Ray Gun Wing,* Cologne, Museum Ludwig, 1979; *Claes Oldenburg: Just Another Room,* Frankfurt, Museum für Moderne Kunst, 1991; *Bruce Nauman*, New York, Rizzoli International, 1989; *John Baldessari*, New York, Rizzoli International, 1990. In 1991 for Rizzoli International she curated a limited edition artist book by Hanne Darboven titled *Urtzeit / Uhrziet*. Among her forthcoming book projects are monographs on Gehry and the performance artist Robert Whitman.

Selected Solo Exhibitions by Claes Oldenburg

1959 Judson Gallery, Judson Memorial Church, New York. *Drawings, Sculptures, Poems by Claes Oldenburg.*

1960 Reuben Gallery, New York. *The Street.*

1961 107 East 2nd Street, New York. *The Store.*

1962 Green Gallery, New York.

1963 Dwan Gallery, Los Angeles.

1964 Sidney Janis Gallery, New York.
Pace Gallery, Boston.
Galerie Ileana Sonnabend, Paris.

1966 Sidney Janis Gallery, New York
Robert Fraser Gallery, London.
Moderna Museet, Stockholm.

1967 Sidney Janis Gallery, New York
Museum of Contemporary Art, Chicago. *Projects for Monuments.*

1968 Irving Blum Gallery, Los Angeles.

1969 Richard Feigen Gallery, Chicago. *Chicago Show.*
The Museum of Modern Art, New York. Travelled to Stedelijk Museum, Amsterdam; Städtische Kunsthalle, Düsseldorf; The Tate Gallery, London.

1970 Sidney Janis Gallery, New York.
Margo Leavin Gallery, Los Angeles. *Works in Edition.*

1971 Pasadena Art Museum, Pasadena, California. *Object Into Monument.* Travelled to University Art Museum, University of California at Berkeley, Berkeley; Nelson-Atkins Museum, Kansas City, Missouri; Des Moines Art Center, Des Moines, Iowa; Philadelphia Museum of Art, Philadelphia; The Art Institute of Chicago, Chicago.

1973 Minami Gallery, Tokyo.

1974 The New Gallery, Cleveland, Ohio. *Standing Mitt with Ball.*
Leo Castelli Gallery, New York.
Yale University Art Gallery, Yale University, New Haven, Connecticut. *The Lipstick Comes Back.*

1975 Kunsthalle Tübingen, Tübingen, Germany. *Zeichnungen von Claes Oldenburg.* Travelled to Kunstmuseum Basel, Basel; Städtische Galerie im Lenbachhaus, Munich; Nationalgalerie, Berlin; Staatliche Museen Preußischer Kulturbesitz, Berlin; Kaiser Wilhelm Museum, Krefeld, Germany; Museum des 20. Jahrhunderts, Vienna; Kunstverein, Hamburg; Städtische Galerie im Stadelschen Kunstinstitut, Frankfurt; Kestner-Gesellschaft, Hannover; Louisiana Museum, Humlebæk, Denmark.
Walker Art Center, Minneapolis. *Oldenburg: Six Themes.* Travelled to The Denver Art Museum, Denver; The Seattle Art Museum, Seattle; Institute of Contemporary Art, and Hayden Gallery, Massachusetts Institute of Technology, Boston; The Art Gallery of Ontario, Toronto.
Mayor Gallery, London. *Erotic Fantasy Drawings.*
Margo Leavin Gallery, Los Angeles. *The Alphabet in LA.*

1976 Leo Castelli Gallery, New York.

1977 Stedelijk Museum, Amsterdam. *Drawings, Watercolours and Graphics.* Travelled to Musée National d'Art Moderne, Centre Georges Pompidou, Paris; Moderna Museet, Stockholm.
Richard Gray Gallery, Chicago.
The Akron Art Institute, Akron, Ohio. *The Inverted Q.*
Museum of Contemporary Art, Chicago. *The Mouse Museum / The Ray Gun Wing: Two Collections / Two Buildings by Claes Oldenburg.* Travelled to Phoenix Art Museum, Phoenix, Arizona; St Louis Art Museum, St Louis, Missouri; Museum of Fine Arts, Dallas; The Whitney Museum of American Art, New York; Rijksmuseum Kröller-Müller, Otterlo, The Netherlands; Museum Ludwig, Cologne.

1978 Margo Leavin Gallery, Los Angeles. *Sculptures 1971-1977.*

1980 Leo Castelli Gallery, New York. *Large-scale Projects 1977-1980.*

1985 Galerie Schmela, Düsseldorf. *Tube Supported by its Contents.*

1986 Palacio de Cristal, Parque del Retiro, Madrid. *El Cuchillo Barco*.

Leo Castelli Gallery, New York. *Props, Costumes and Designs from the Performance* Il Corso del Coltello *by Claes Oldenburg, Coosje van Bruggen, Frank O. Gehry*.

Solomon R. Guggenheim Museum, New York. *The Knife Ship II*.

1987 Northern Centre for Contemporary Art, Sunderland, England. *A Bottle of Notes and Some Voyages*. Travelled to the Henry Moore Centre for the Study of Sculpture, Leeds City Art Gallery, Leeds, England; The Serpentine Gallery, London; The Glynn Vivian Art Gallery and Museum, Swansea, Wales; Palais des Beaux-Arts, Brussels; Wilhelm-Lehmbruck Museum, Duisburg, Germany; IVAM Centro Julio González, Valencia, Spain; Tampereen Nykytaiteen Museo, Tampere, Finland.

Museum Haus Lange, Krefelder Kunstmuseum, Krefeld, Germany. *The Haunted House*.

Musée National d'Art Moderne, Centre Georges Pompidou, Paris. *Le couteau navire décors, costumes, dessins:* Il Corso del Coltello, *de Claes Oldenburg, Coosje van Bruggen et Frank O. Gehry*.

Galerie Konrad Fischer, Düsseldorf. *Piano / Hammock*.

1988 Museum of Contemporary Art, Los Angeles. *The Knife Ship II*.

Margo Leavin Gallery, Los Angeles. *Props, Costumes and Designs from the Performance* Il Corso del Coltello *by Claes Oldenburg, Coosje van Bruggen, Frank O. Gehry*.

Palais des Beaux-Arts, Brussels. *Drawings 1959-1988*. Travelled to Musée d'Art Contemporain, Nimes, France; IVAM Centro Julio González, Valencia, Spain.

1989 Musée d'Art Moderne, Saint-Etienne, France. *From the Entropic Library*.

1990 Carl Solway Gallery, Cincinnati, Ohio. *A Complete Survey of Sculptures in Edition 1963-1990*

Galleria Christian Stein, Milan. *The European Desk Top*.

Brooke Alexander Editions, New York. *Multiples in Retrospect 1964-1990*.

Leo Castelli Gallery, New York (with Coosje van Bruggen).

Castelli Graphics, New York. *Lithographs from Gemini G.E.L. 1988-1990*.

The Mayor Gallery, London. *8 Sculptures 1961-1987*.

1991 Seagram Plaza, New York. *Monument to the Last Horse*.

1992 Portikus, Frankfurt. *Multiples 1964-1990*. Travelled to Lenbachhaus, Munich; Hochschule für angewandte Kunst, Vienna; Musée Municipal, La Roche-sur-Yon, France; Musée d'Art Moderne, Saint-Etienne, France; Neues Museum Weserburg, Bremen, Germany, as *Claes Oldenburg: Geometrische Mäuse und vieles mehr... Multiples, Objekte, Zeichnungen;* Tel Aviv Museum of Art, Tel Aviv, as *Claes Oldenburg: Multiples and Notebook Pages;* Deichtorhallen Hamburg, as part of the group exhibition *Das Jahrundert des Multiple;* Middlesbrough Art Gallery, Middlesbrough, England, as *Claes Oldenburg: The Multiples Store;* Kettle's Yard, Cambridge, England; Aberystwyth Arts Centre, Aberystwyth, Wales; Peter Scott Gallery, Lancaster, England; York City Art Gallery, York, England; Maclaurin Art Gallery, Ayr, Scotland; The Gallery, Ormeau Baths, Belfast, N. Ireland.

Cleveland Center for Contemporary Art, Cleveland, Ohio. *Recent Sculpture*.

Museum für Gegenwartskunst, Basel. *Die frühen Zeichnungen*.

Walker Art Center, Minneapolis. *From the Studio*. Travelled to Musée Cantini, Marseille, France.

The Pace Gallery, New York.

1993 Gemini G.E.L. at Joni Moisant Weyl, New York. *Claes Oldenburg: Recent Print and Sculpture Editions*.

1994 The Pace Gallery, New York.

1995 National Gallery of Art, Washington, DC. *Claes Oldenburg: An Anthology*. Travelled to The Museum of Contemporary Art, Los Angeles; Solomon R. Guggenheim Museum, New York; Kunst-und Ausstellungshalle der Bundesrepublik Deutschland, Bonn; Hayward Gallery, London.

1997 Madison Art Center, Madison, Wisconsin. *Claes Oldenburg: Printed Stuff;* Columbus Museum of Art, Columbus, Ohio; The Detroit Institute of Arts, Detroit, Michigan.

Sited Outdoor Works

1969–73
Three-way Plug
Cor-Ten and bronze
9ft 6ins x 6ft 6ins x 4ft 9ins (2.9 x 1.98 x 1.45m)
Oberlin College, Oberlin, Ohio (1 / 3)
St Louis Museum of Art (2 / 3)
Private Collection, Wynnewood, Pennsylvania (3 / 3)

1969 *Giant Ice Bag*
Steel, aluminium, cast, resin, vinyl, wood, machinery
16ft 6ins x 18ft x 18ft (5.02 x 5.49 x 5.49m)
Private Collection, Japan
First shown at 1970 World's Fair, Osaka, Japan;
also shown at Los Angeles County Museum of Art;
Dallas Museum; Baltimore Museum; National Gallery of
Art, Washington, DC; and other venues.

1969–70
Geometric Mouse, Scale A
Painted steel and aluminium
12ft x15ft x 7ft (3.66 x 4.57 x 2.13m)
Albany Mall, Albany, New York (Black 1 / 6)
Southern Methodist University, Dallas (Black 2 / 6)
Hirshhorn Museum and Sculpture Garden,
Washington, DC (Black 3 / 6)
Moderna Museet, Stockholm (yellow and blue 4 / 6)
Walker Art Center, Minneapolis (yellow and blue 5 / 6)
The Museum of Modern Art, New York (white 6 / 6)

1971 *Geometric Mouse, Scale X, Red*
Painted steel
18ft (5.49m) height
Jesse H. Jones Public Library, Houston
(Previously installed in Newport, Rhode Island, and
Hammarskjold Plaza and Sculpture Garden, New York,
April-June 1974)

1973 *Standing Mitt with Ball*
12ft (3.66m) height
Storm King Art Center, Mountainville, New York
(Previously installed at Wave Hill, Bronx, New York)

1975 *Alphabet / Good Humor*
Painted fibreglass, resin, bronze
12ft x 5ft 8ins x 2ft 4ins (3.66 x 1.73 x .0.71m)
Private Collection, Chicago, (1 / 2)
Private Collection, Berlin (2 / 2)
(Previously sited in private collection, Los Angeles)

1975 *Colossal Ashtray*
Lead, steel filled with urethane foam on steel base
6ft 6ins x 14ft 6ins x 13ft (1.98 x 4.42 x 3.92m)
Neue Galerie – Sammlung Ludwig, Aachen, Germany
(First shown as part of touring exhibition *Oldenburg:
Six Themes*; previously installed at Centre Georges
Pompidou, Paris, and Nordjyllands Kunstmuseum,
Aalborg, Denmark)

1976–90
Inverted Q
Painted concrete or resin
72 x 70 x 63 ins (183 x 178 x 160cm)
Akron Art Institute, Akron, Ohio (Pink edition 1 / 4)
Städtisches Museum Abteiberg, Münchengladbach
Germany (Pink edition 2 / 4)
Private collection, Santa Cruz, California
(Pink edition 3 / 4)
Samsung Corporation, Seoul, Korea
(Pink edition, cast iron 4 / 4)
Private Collection, New York
(Black edition, cast resin 1 / 2)
Yokohama Museum, Japan
(Black edition, cast resin 2 / 2)
Edwin A. Ulrich Museum of Art, Wichita State
University, Wichita, Kansas
(White, cast resin – unique)

1979 *Wayside Drainpipe*
Cor-Ten, cement, found rocks
19ft 8ins x 8ft 1ins x 6ft 6ins (6 x 2.464 x 1.841m)
North Haven, Connecticut
(Previously installed on Doberman estate,
Westphalia, Germany)

1985 *Tube Supported by its Contents*
Painted bronze and steel
15ft (4.57m) height
Lohausen Park, Düsseldorf

1989 *Knife Slicing through Wall*
Stainless steel, steel, stucco
Blade: 6ft x 11ft 6ins (1.83 x 3.51m) height and length
Margo Leavin Gallery, Los Angeles (1 / 2)

Large-scale Projects with Coosje van Bruggen

1969–74
Lipstick (Ascending) on Caterpillar Tracks
Cor-Ten, painted steel and aluminium, cast resin
24ft x 11ft x 13ft (7.31 x 3.35 x 3.96m)
Yale University, Samuel Morse College, New Haven,
Connecticut.
(Originally sited in Beinecke Plaza, April 15, 1969;
resited in Samuel Morse College, October 17, 1974)

1971–76
Trowel I
Steel painted with polyurethane enamel (blue)
41ft 9ins x 11ft 3^1/$_8$ins x 14ft 6^3/$_4$ins
(12.73 x 3.43 x 4.44m)
Sited: 38ft 4^1/$_2$ins x 11ft 3^1/$_8$ins x 7ft 4^1/$_2$ins
(11.7 x 3.43 x 2.25m)
Rijksmuseum Kröller-Müller, Otterlo, The Netherlands;
earlier version coated with zinc primer, finished with
aluminium compound shown in *Sonsbeek 71*, Arnhem,
the Netherlands, 1971.

1976–82
Trowel II
Cor-Ten steel painted with polyurethane enamel (brown)
41ft 9ins x 11ft 3^1/$_8$ins x 14ft 6^3/$_4$ins
(12.73 x 3.43 x 4.44m)
Sited: 37ft x 11ft 3^1/$_8$ins x 7ft 4^1/$_2$ins
(11.28 x 3.43 x 2.25m)
Donald M. Kendall Sculpture Gardens at Pepsico
Purchase, New York (II:July 1982)

1976 *Clothespin*
Cor-Ten and stainless steel
45ft x 6ft x 4ft (13.7 x 1.82 x 1.22m)
Centre Square, Philadelphia

1977 *Batcolumn*
Steel and aluminium painted with polyurethane enamel
96ft 8ins x 9ft 9ins (29.46 x 2.97m) diameter,
on base 4ft x 10ft (1.22 x 3.05m) diameter
Harold Washington Social Security Center, 600 West
Madison Street, Chicago

Pool Balls
Reinforced Concrete
Three Balls: each 11ft 6ins (3.5m) diameter
Aaseeterrassen, Münster, Germany

1979 *Crusoe Umbrella*
Cor-Ten steel painted with polyurethane enamel
37ft x 37ft x 58ft (11.28 x 11.28 x 17.68m)
Sited: 33ft x 37ft x 56ft (10.06 x 11.28 x 17.07m)
Nollen Plaza, Civic Center of Greater Des Moines,
Des Moines, Iowa

1981 *Flashlight*
Steel painted with polyurethane enamel
38ft 6ins x 10ft 6ins (11.73 x 3.2m) diameter
University of Nevada, Las Vegas

Split Button
Aluminium painted with polyurethane enamel
16ft (4.88m) diameter x 10^3/$_{16}$ins (0.26m) thick
Height when sited: 4ft 11ins (1.5m)
Levy Park, University of Pennsylvania, Philadelphia

1982 *Hat in Three Stages of Landing*
Aluminium and steel painted with polyurethane enamel
Three 'hats' each 9ft 5ins x 18ft x 15ft 5ins
(2.87 x 5.49 x 4.7m).
Each 'hat' is supported on two poles at different
heights: 19ft 3ins, 12ft 10ins, 6ft 0^{11}/$_{16}$ins
(5.87, 3.91, 1.85m) equidistant from one another, over
a total of 162ft (49.38m)
Sherwood Park, Salinas, California

Spitzhacke (Pick-Axe)
Steel painted with polyurethane enamel
36ft 9ins x 44ft 6ins x 3ft 8ins (11.2 x 13.56 x 1.12m)
Sited: 43ft 5ins x 42ft 7ins x 11ft 4^1/$_2$ins
(13.32 x 12.98 x 3.47m)
Kassel, Germany

1983 *Gartenschlauch (Garden Hose)*
Steel painted with polyurethane enamel
Faucet: 35ft 5ins x 8ft 11^1/$_2$ins x 7ft 0^5/$_8$ins
(10.8 x 2.73 x 2.15m)
Hose: 410ft (124.97m) long x 19^{11}/$_{16}$ins (0.50m)
diameter, over an area of approximately 6,000 sq ft
(557.4m^2)
Stühlinger Park, Freiburg-im-Breisgau, Germany

Screwarch
Aluminium painted with polyurethane enamel
12ft 8ins x 21ft 6ins x 7ft 10ins (3.86 x 6.55 x 2.39m)
Museum Boymans-van Beuningen, Rotterdam,
The Netherlands

*Cross-section of a Toothbrush with Paste, in a Cup, on
a Sink: Portrait of Coosje's Thinking*
Steel and cast iron painted with polyurethane enamel
19ft 8ins x 9ft 2^1/$_4$ins x 6^{11}/$_{16}$ins (6 x 2.8 x 0.17m)
Haus Esters, Krefeld, Germany

1984 *Stake Hitch*
Stake: aluminium, steel, epoxy, painted with polyurethane
enamel. Rope: polyurethane foam, plastic materials,
fibreglass-reinforced plastic, painted with latex.
Stake with knot, upper floor:
13ft 6ins x 18ft 2ins x 4ft 7ins (4.11 x 5.54 x 4.45m).
Stake, lower floor:
12ft 9^1/$_2$ins x 5ft x 3ft (3.9 x 1.52 x 0.91m).
Rope: 20ins (0.51m) diameter; length, knot to ceiling:
40ft (12.19m). Total height, including upper and lower
floor: 53ft 6ins (16.31m)
Dallas Museum of Art

Balancing tools
Steel painted with polyurethane enamel
26ft 3ins x 29ft 6ins x 19ft 10ins (8 x 9 x 6.05m)
Vitra International AG, Weil am Rhein, Germany

1985–86
Coltello Ship I & II (Knife Ship). With Frank O. Gehry.
Wood, steel and plastic
35ft 6ins x 83ft x 31ft 10ins (10.7 x 25.3 x 9.70m) (variable)
Orginally made for the performance of *Il Corso del
Coltello*, Venice, Italy, September 6, 1985.
Solomon R. Guggenheim Museum, New York (I)
The Museum of Contemporary Art, Los Angeles (II)

1985 *Toppling Ladder with Spilling Paint*
Steel and aluminium painted with polyurethane enamel
14ft 2ins x 10ft 8ins x 7ft 7ins (4.32 x 3.25 x 2.31m)
Loyola Law School, Los Angeles

1988 *Spoonbridge and Cherry*
Aluminium painted with polyurethane enamel and
stainless steel
29ft 6ins x 51ft 6ins x 13ft 6ins (9 x 15.7 x 4.1m)
Minneapolis Sculpture Garden, Walker Art Center, Minneapolis

1990 *Dropped Bowl, with Scattered Slices and Peels*
Reinforced concrete, steel, fibreglass-reinforced plastic,
painted with polyurethane enamel, stainless steel.
Seventeen parts (eight bowl fragments, four peels,
five orange sections).
Overall: 16ft 9ins x 91ft x 105ft (5.11 x 27.7 x 32m)
Metro-Dade Open Space Park, Miami

1991 *Bicyclette Ensevelie (Buried Bicycle)*
Steel, aluminium, fiberglass, painted with
polyurethane enamel
Four parts. Wheel: 9ft 2$^{1}/_{4}$ins x 53ft 4$^{3}/_{16}$ins x 10ft 4ins
(2.8 x 16.26 x 3.15m);
handlebar and bell: 23ft 8$^{1}/_{4}$ins x 20ft 4$^{7}/_{8}$ins x 15ft
6$^{5}/_{8}$ins (7.22 x 6.22 x 4.74m);
seat: 11ft 3$^{3}/_{16}$ins x 23ft 9ins x 13ft 7ins
(3.45 x 7.24 x 4.14m);
pedal: 16ft 3$^{11}/_{16}$ins x 20ft 1$^{5}/_{16}$ins x 6ft 10$^{11}/_{16}$ins
(4.97 x 6.13 x 2.1m)
in an area approximately 150ft 11ins x 71ft 2$^{5}/_{16}$ins
(46 x 21.7m)
Parc de La Villette, Paris

Binoculars, part of *Chiat / Day / Mojo Offices.*
With Frank O. Gehry.
Steel Frame. Exterior: concrete and cement plaster
painted with elastomeric paint. Interior: gypsum plaster
45ft x 44ft x 18ft (13.72 x 13.41 x 5.49m)
Chiat / Day, Inc., 340 Main Street, Venice, California

Free Stamp
Steel and aluminium painted with polyurethane enamel
28ft 9$^{5}/_{8}$ins x 26 x 49ft (8.78 x 7.92 x 14.94m)
Willard Park, Cleveland, Ohio

Monument to the Last Horse
Painted aluminium, urethane foam, resin
19ft 6ins x 17ft x 12ft 6ins (5.9 x 5.18 x 3.81m) height
Chinati Foundation, Marfa, Texas
(Previously installed at Seagram Plaza, New York)

1992 *Mistos (Match Cover)*
Steel, aluminium, fibreglass-reinforced plastic, painted
with polyurethane enamel
Overall: 68ft x 33ft x 43ft 4ins
(20.73 x 10.06 x 13.21m)
Detached matches:
(1) 9ft 2ins x 37ft 1in x 9ft 7ins (2.79 x 11.3 x 2.92m)
(2) 14ft 10ins x 30ft 3ins x 10ft (4.52 x 9.22 x 3.05m)
(3) 7ft 6ins x 28ft 4ins x 18ft 9ins (2.29 x 8.64 x 5.72m)
(4) 7ft 11ins x 25ft 10ins x 19ft 2ins (2.41 x 7.78 x 5.84m)
(5) 17ft 4ins x 35ft x 14ft 5ins (5.28 x 10.67 x 4.39m)
Olympic Village, Valle d'Hebron, Barcelona

1993 *Bottle of Notes*
Steel painted with polyurethane enamel
30ft x 16ft x 10ft (9.14 x 4.88 x 3.05m)
Central Gardens, Middlesbrough, England

1994 *Inverted Collar and Tie*
Fibreglass-reinforced plastic painted with gelcoat, steel,
polymer concrete
39ft x 27ft 9ins x 12ft 7$^{1}/_{2}$ins (11.89 x 8.46 x 3.85m)
West End Str. 1, Mainzer Landstrasse 58, Frankfurt am Main

Shuttlecocks
Aluminium and fibreglass-reinforced plastic painted
with polyurethane enamel
Four shuttlecocks, each 17ft 10$^{3}/_{4}$ins (5.45m) x 15ft 0$^{3}/_{4}$ins
(4.59m) crown diameter and 4ft (1.22m) nose diameter.
Sited in different positions on the grounds of The
Nelson-Atkins Museum of Art. Near entrance:
19ft 2$^{1}/_{2}$ins x 17ft 5ins x 15ft 0$^{3}/_{4}$ins (5.85 x 5.31 x 4.59m);
on terrace: 20ft x 15ft 10ins x 15ft 0$^{3}/_{4}$ins (6.1 x 4.83 x 4.59m);
on upper lawn: 17ft 10$^{3}/_{4}$ins x 15ft 0$^{3}/_{4}$ins x 15ft 0$^{3}/_{4}$ins
(5.45 x 4.59 x 4.59m); on lower lawn:
18ft 3$^{1}/_{2}$ins x 18ft 10ins x 15ft 0$^{3}/_{4}$ins (5.58 x 5.74 x 4.59m)
The Nelson-Atkins Museum of Art, Kansas City, Missouri

1996 *Houseball*
Fibreglass-reinforced plastic, jute netting, painted with
polyester gelcoat; stainless steel, urethane and PVC foams
27ft 6ins x 24ft 4ins (8.4 x 7.4m) height x diameter
Temporarily sited in front of the Kunst-und Ausstellungshalle
der Bundesrepublik Deutschland, Bonn, during the exhibition
Claes Oldenburg: An Anthology.
Private Collection

Saw, Sawing
Fibreglass-reinforced plastic, painted with polyester gelcoat
and polyurethane clear coat, steel, epoxy resin, urethane and
PVC foams
50ft 8ins x 4ft 9ins x 40ft (15.44 x 1.45 x 12.2m)
Tokyo International Exhibition Center, Big Site, Tokyo

Golf / Typhoon
Steel and fibreglass-reinforced plastic painted with
polyurethane enamel
20ft 2ins x 5ft 7ins x 5ft 6ins (6.15 x 1.7 x 3.66m)
Mr and Mrs Len Riggio

Torn Notebook
Aluminium, steel, stainless steel painted with
polyurethane enamel
Three parts: 21ft 10 ins x 23ft x 26ft 1in
(6.65 x 6.4 x 7.95m);
10ft x 14ft 1in x 7ft 1in (3.04 x 4.29 x 2.16m);
11ft 8ins x 8ft 7ins x 8ft 2ins (3.56 x 2.62 x 2.49m)
Madden Garden, University of Nebraska, Lincoln, Nebraska

Performances

1960 *Snapshots from the City*, Judson Gallery, New York.

Blackouts (in four parts: *Chimneyfires, Erasers, The Vitamin Man*, and *Butter and Jam*),
Reuben Gallery, New York.

1961 Set and costume designs for performance by Aileen Passloff and Dance Company,
Fashion Institute of Technology, New York.

Circus (Ironworks/Fotodeath) (included *Pickpocket*, a slide presentation, during intermission), Reuben Gallery, New York.

1962 Designs for performance by Aileen Passloff and Dance Company, Fashion Institute of Technology, New York.

Ray Gun Theater (comprised of ten performances), Ray Gun Mfg. Co., 107 East Second Street, New York.
Store Days I; Store Days II; Nekropolis I, Nekropolis II, Injun (N.Y.C.) I; Injun (N.Y.C.) II; Voyages I; Voyages II, World's Fair I; World's Fair II.

Injun, The Dallas Museum for Contemporary Arts.

Sports, Green Gallery, New York.

1963 *Gayety*, Lexington Hall, University of Chicago

Stars: A Farce for Objects, The Washington Gallery of Modern Art, Washington, D.C.

Autobodys, parking lot of the American Institute of Aeronautics and Astronautics, Los Angeles.

1965 *Washes*, Al Roon's Health Club, New York.

Moveyhouse, Forty-first Street Theater, New York.

Massage, Moderna Museet, Stockholm.

1985 *Il Corso del Coltello* (with Frank O. Gehry and Coosje van Bruggen), Campo dell' Arsenale, Venice, Italy.

1988 *Coltello Recalled: Reflections on a Performance* (with Frank O. Gehry and Coosje van Bruggen), The Japanese American Cultural and Community Center, Los Angeles.

Selected Bibliography

Gene Baro. *Claes Oldenburg: Drawing and Prints.* Lausanne: Publications IRL (A Paul Bianchini Book); and London: Chelsea House Publishers, 1969.

Barbara Rose. *Claes Oldenburg.* New York: The Museum of Modern Art, 1970.

Barbara Haskell with texts by the artist. *Claes Oldenburg: Object into Monument.* Pasadena Art Museum, 1971.

Ellen H. Johnson. *Claes Oldenburg.* New York: Penguin Books, 1971.

Götz Adriani, Dieter Koepplin, Barbara Rose. *Zeichnungen von Claes Oldenburg.* Basel: Kunstmuseum Basel; and Tübingen: Kunsthalle Tübingen, 1975.

Martin Friedman, and interview with Claes Oldenburg. *Oldenburg: Six Themes.* Minneapolis, Minnesota: Walker Art Center, 1975.

Coosje van Bruggen, Ad Petersen. *Claes Oldenburg: Tekeningen, aquarellen en grafiek.* Amsterdam: Stedelijk Museum, 1977, (foreword by Edy de Wilde); Paris: Musée National d'Art Moderne, Centre Georges Pompidou, (foreword by Pontus Hultén); Stockholm: Moderna Museet, (foreword by Björn Sprinfeldt).

Coosje van Bruggen. *Claes Oldenburg: Mouse Museum / Ray Gun Wing.* Cologne: Museum Ludwig, 1979.

Coosje van Bruggen, Claes Oldenburg, R. H. Fuchs. *Claes Oldenburg: Large-Scale Projects, 1977-1980. A chronicle by Coosje van Bruggen & Claes Oldenburg, based on notes, statements, contracts, correspondence, and other documents related to the works.* New York: Rizzoli International Publications, Inc., 1980.

Cor Blok. *Claes Oldenburg: Het Schroefboog-projekt: een opdracht van Museum Boymans-van Beuningen, Rotterdam 1978-82. The Screwarch Project commissioned by Museum Boymans-van Beuningen, Rotterdam 1978-82.* Rotterdam: Museum Boymans-van Beuningen, 1983.

Claes Oldenburg, Gerhard Storck. *Claes Oldenburg: Cross Section of a Toothbrush with Paste, in a Cup on a Sink: Portrait of Coosje's Thinking.* Krefeld, Germany: Krefelder Kunstmuseen, 1985.

Claes Oldenburg, Coosje van Bruggen, Frank O. Gehry, Germano Celant. *El Cuchillo Barco, de Il Corso del Coltello.* Milan: Electa; and Madrid: Ministerio de Cultura, 1986.

Germano Celant, Coosje van Bruggen, Claes Odenburg. *The Course of the Knife / Il Corso del Coltello.* Milan: Electa, 1986.

Gerhard Storck, Coosje van Bruggen. *The Haunted House.* Krefeld, Germany: Krefelder Kunstmuseen, 1987.

Germano Celant, Claes Oldenburg, Coosje van Bruggen. *A Bottle of Notes and Some Voyages.* Sunderland: Northern Centre for Contemporary Art; Leeds: The Henry Moore Centre for the Study of Sculpture, Leeds City Art Galleries; New York: Rizzoli International Publications, Inc., 1988.

Coosje van Bruggen. *Claes Oldenburg: Dibujos / Drawings 1959-1989.* Valencia, Spain: IVAM, Instituto Valenciano de Arte Moderno, 1989.

Coosje van Bruggen. *Claes Oldenburg: Nur ein anderer Raum.* Frankfurt: Museum für Moderne Kunst, 1991.

Arthur Solway, Thomas Lawson, Claes Oldenburg, David Platzker. *Claes Oldenburg: Multiples in Retrospect, 1964-1990.* New York: Rizzoli International Publications, Inc., 1991.

Dieter Koepplin. *Claes Oldenburg: Die frühen Zeichnungen.* Basel: Museum für Gegenwartskunst, 1992.

Thomas Lawson, David Platzker. *Claes Oldenburg: Multiples 1964–1990.* Frankfurt am Main: Portikus, 1992 (German edition), 1993 (French edition).

Arne Glimcher and Claes Oldenburg. *Claes Oldenburg.* New York: The Pace Gallery, 1992.

Claes Oldenburg, Coosje van Bruggen, Susan P. Casteras, Vincenty Scully, Gerhard Storck, Donald Judd, Richard Cork. *Claes Oldenburg / Coosje van Bruggen: Large-Scale Projects.* New York: The Monacelli Press, New York, 1994.

Marla Prather, Germano Celant, Mark Rosenthal, Dieter Koepplin, Claes Oldenburg. *Claes Oldenburg.* New York: Guggenheim Museum Publications, 1995.

Susan May, Claes Oldenburg, David Platzker. *Claes Oldenburg: The Multiples Store.* London: The South Bank Centre, 1996.

Selected Books by Claes Oldenburg

Store Days. New York, Villefranche-sur-mer, Frankfurt am Main: Something Else Press, Inc., 1967.

Claes Oldenburg, interview with artist by Paul Carroll. *Proposals for Monuments and Buildings 1965-69*. Chicago: Big Table Publishing Company, 1969.

Claes Oldenburg. *Notes in Hand*. Petersburg Press, 1971.

Claes Oldenburg. *Raw Notes*. Halifax, Nova Scotia, Canada: The Press of the Nova Scotia College of Art and Design, 1973.

Claes Oldenburg and Coosje van Bruggen. *Sketches and Blottings toward the European Desk Top*. Milan and Turin: Galleria Christian Stein; and Florence: Hopeful Monster, 1990.

Selected Films

Sort of a Commercial for an Ice Bag. Directed by Michel Hugo. Cinematography by Eric Saarinen. Edited by John Hoffman. Sound by Howard Chesley. 16mm color film with sound, 30 minutes. Produced by Gemini GEL, Los Angeles, 1970.

Claes Oldenburg. Edited by Lana Jokel. Cinematography by Nicholas Proferes. Addtional cinematography by Christian Blackwood and Seth Schneidman. Sound by James Musser. Production Manager: Stephen Westheimer. 16mm color film with sound, 52 minutes. Produced by Blackwood Productions, Inc., New York, 1973-74.

School Bus Yellow / Adirondack Green. Directed and produced by Coosje van Bruggen and Machteld Schrameijer. Cinematography by Francis Freedland, Jesper Sorensen, and Vibeke Winding. Sound by Robert Ghiraldini. Edited by Donald George Klocek. Music by Al Scotti. 16mm color film with sound, 49 minutes. Distributed by Store Days Inc., New York, 1982.

Claes Oldenberg / Coosje van Bruggen: Large-Scale Projects. Produced, directed and edited by Lana Jokel and Nick Doob. Cinematography by Nick Doob. 16mm color film with sound, 56 minutes. Distributed by Lana Jokel, New York, 1991.

Ein Schlips steht Kopf: Ein Film mit Claes Oldenburg und Coosje van Bruggen, 1994. 16 mm color film with sound, 21 minutes. Directed by Erwin Leiser and Vera Leiser. Filmed by Peter Warneke. Sound by Peter Warneke and Wolfgang Widmer. Edited by Werner Wullschleger. Produced by Erwin Leiser Filmproduktion, Zurich; Deutsche Genossenschaftsbank, Frankfurt; Südwestfunk, Baden-Baden; and Hessischer Rundfunk, Frankfurt. German and English editions. Distributed by Erwin Leiser Filmproduktion, Zurich.

Getting the Message. Filmed by Mike Parker, Tim Piper, and Tal Larishe. Sound by John Cook and Gail Westwood. Edited by Howard Beebe. Directed and produced by Peter Chapman. Color video with sound, 30 minutes. 1994. Currently not distributed.

Claes Oldenburg. Produced and directed by Gerald Fox. Edited by Jonathan Cooke. Associate producer Sarah Wason. Executive producer Ultan Guilfoyle. Color video, with sound, 54 minutes. Distributed by Phaidon Press, London.

Selected Articles about *Bottle of Notes*

Bickers, Patricia, interview with Claes Oldenburg. "Claes Oldenburg," *Art Monthly* (London), no. 171 (November 1993): cover, pp. 3, 5, 7, 9, 11.

Boswell, Guy. "Praise and Scorn Poured on 'Landmark' Bottle Sculpture," *Northern Echo* (Middlesbrough, England), September 15, 1993.

"Bottle Good for Us," *Evening Gazette* (Middlesbrough, England), September 8, 1993.

"A Bottle of Notes – Proposal for a Large-scale Project in Middlesbrough, England, 1988" (2d, repro, cover). *Artforum* (New York) 26, no. 7, March 1988: cover, p.1.

"A Bottle of Pride," *Evening Gazette* (Middlesbrough, England), June 29, 1994.

"Comment: A Lot of Bottle," *Evening Gazette* (Middlesbrough, England), March 16, 1989.

"Cook Rides Storm in Steel Bottle," *Northern Echo* (Middlesbrough, England), April 23, 1988.

Cork, Richard. "Positive Message in a Bottle," *Times* (London), September 22, 1993.

"Could You Bottle This?" *Evening Gazette* (Middlesbrough, England), September 20, 1993.

Gayford, Martin. "Mighty Message on a Bottle," *Daily Telegraph* (London), September 22, 1993.

Gent, Bernard. "Lotsa Bottle Cash for Art in Park," *Northern Echo* (Middlesbrough, England), March 13, 1989.

"The Giant Bottle Comes to Town," *Herald & Post* (Middlesbrough, England), September 15, 1993.

Graham-Dixon, Andrew. "Bottle of Pop," *Vogue* (London) 154, no.8, no.2317, August 1990: pp.128-135.

Graham-Dixon, Andrew. "A Lot of Bottle," *Independent* (London), September 28, 1993.

Harrison, Josie. "Cook's Tour," *Communist Party Weekly* (London), July 9, 1988.

"Kooky Cook Tribute," *Times* (London), September 5, 1993.

"The Leaning Bottle of Middlesbrough," *Guardian* (London), September 17, 1993.

Lee, David. "Here's Hoping Someone Gets that Message in the Bottle," *Northern Echo* (Middlesbrough, England), September 25, 1993.

"Lotta Bottle!" *Evening Gazette* (Middlesbrough, England), April 26, 1988.

"Lotta Bottle for a Hero!" *Daily Mirror* (London), April 23, 1988.

McGeary, Mike. "A Bottle of Some Note!" *Evening Gazette* (Middlesbrough, England), September 15, 1993.

McIlroy, A. J. "American Pop Artist Defends Cook Bottle," *Daily Telegraph* (London), April 26, 1988.

"Message in a Bottle," *Shields Gazette* (South Shields, England), March 13, 1993.

"Message in a Bottle," *Middlesbrough News* (Middlesbrough Borough Council, Middlesbrough, England), no.51, October 1993: cover, p.2.

"Message in a Bottle," *Time Magazine* (New York), October 4, 1993.

"Message on a Bottle," *Times* (London), March 28, 1991.

Morrison, Richard. "Putting People in the Picture," *Times* (London), June 30, 1994.

Paul, Julia. "Lotta Bottle," *Evening Gazette* (Middlesbrough, England), September 25, 1993.

"Sculptor Uncorks His New Creation," *Northern Echo* (Middlesbrough, England), May 3, 1989.

Welford, Joanne. "Message in a Bottle is Just Write," *Journal* (Newcastle, England), June 24, 1993.

Whetstone, David. "Criticism Without the Facts," *Journal* (Newcastle, England), April 29, 1988.

Whetstone, David. "Pop Sculptor with a Serious Intent," *Journal* (Newcastle, England), May 2, 1988.

Yelland, David. "Message in a Bottle," *Northern Echo* (Middlesbrough, England), July 25, 1988.

Notes to Message in a Bottle
Richard Cork
(Pages 13 – 28)

[1] 'With rare and shining exceptions', Roger Fry wrote in 1912, 'committees seem to be at the mercy of the lowest common denominator of their individual natures, which is dominated by fear of criticism; and fear and its attendant, compromise, are bad masters of the arts.' ('Art and Socialism', reprinted in *Vision and Design*, London 1920, Pelican ed. 1961, p.57.)

[2] 'This remarkable place', declared Gladstone, 'the youngest child of England's enterprise, is an infant – but an infant Hercules.' (See *Middlesbrough Official Guide*, Middlesbrough n.d., p.21.)

[3] *The Captain Cook Birthplace Museum*, Derby 1982, p.16.

[4] The Whitby statue, the work of the sculptor John Tweed, was unveiled in 1912.

[5] The Easby obelisk was erected in 1827 by Robert Campion of Whitby.

[6] In dubious exchange, the Great Ayton Memorial was built on the site of the Cook family cottage with stone taken from near Point Hicks, Victoria, the first part of Australia to be sighted by Cook.

[7] Subsequently known simply as *Gulliver's Travels*.

[8] Jonathan Swift, *Gulliver's Travels*, New York ed. 1962, p.35.

[9] Claes Oldenburg, 'Aboard the Broome Street', *A Bottle of Notes and Some Voyages*, Sunderland and Leeds 1988, p.15.

[10] Ibid., p.13.

[11] Ibid., p.12.

[12] Jonathan Swift, *Gulliver's Travels*, op. cit., p.150.

[13] The full text of the 1961 statement is reprinted in the catalogue of the Oldenburg exhibition, organised by the Museum of Modern Art, New York, and then shown at the Tate Gallery, London, 1970, pp.11-12.

[14] For an illuminating essay on the Krefeld exhibition, see Coosje van Bruggen, 'Ghosting', *A Bottle of Notes and Some Voyages*, op. cit., pp.188-209.

[15] Edgar Allan Poe, *Tales of Mystery and Imagination*, London, Everyman ed. 1968, p.262.

[16] Ibid., p.264.

[17] Ibid., p.266.

[18] Ibid., p.267.

[19] Dance's portrait of Cook is owned by the National Maritime Museum, Greenwich.

[20] Claes Oldenburg, *A Bottle of Notes and Some Voyages*, op. cit., p.224.

[21] In a letter from Oldenburg and van Bruggen to the author, August 1993, they wrote: 'A bottle is not complete without a cork, especially if there is a message inside or a genie (that would be Coosje, as a swirl of solidified essence). But what function does the cork serve in view of the fact that the Bottle is full of holes? It's just part of the representation of "bottleness".'

[22] Ibid.

[23] 'For Coosje the seagull is a symbol of independence and survival.' Ibid.

[24] In their letter to the author, Oldenburg and van Bruggen pointed out that, so far as the letters 'CO' were concerned, 'now you're implicated too'.

[25] See footnote 13.

[26] Claes Oldenburg, 'Notes towards a Large-scale Project for Middlesbrough', *A Bottle of Notes*, op. cit., p.220.

[27] Councillor Hazel Pearson, comment reported by *The Guardian*, 17 September 1993.

[28] See footnote 13.·

[29] Claes Oldenburg and Coosje van Bruggen, letter to author, op. cit.

[30] Ibid.

[31] As early as 1961 Oldenburg wrote: 'It is important to me that a work of art be constantly elusive, mean many different things to many different people. My work is always on its way between one point and another. What I care about most is its living possibilities' (reprinted in the catalogue of the 1970 Oldenburg exhibition, op. cit., p.6).

[32] Claes Oldenburg and Coosje van Bruggen, letter to author, op. cit.

[33] Ibid.

For help during the preparation of this essay, special thanks are due to Charlie Alcock, Gordon Bates, Peter Davies, Tony Duggan, Les Hooper, Stephanie Smith and, above all, Claes Oldenburg and Coosje van Bruggen.

Acknowledgements

Many individuals and organisations have provided support to realise the *Bottle of Notes*. Their help is gratefully acknowledged and in particular those mentioned below.

Sponsors
British Steel, Chemoxy Plc, Tees Storage Company, Godington Charitable Trust, Coopers Lybrand, National Westminster Bank PLC, Royal Mail, Tees Towing Company, Priest Furnaces, Marathon Oil UK Ltd, The Foundation for Sports and the Arts, British/Australian Bicentennial Trust, Tom Bendham, Barker and Stonehouse, RM Burton Charitable Trust, Ove Arrup and Partners, AV Dawson, Business Sponsorship Incentive Scheme, North East Sponsors Club, Northern Arts, Henry Moore Foundation, Middlesbrough Council, International Paints, Metal Spinners (Newcastle) Ltd, Grayston White and Sparrow Ltd.

Fabricators
AMARC / Hawthorn Leslie Fabrications Ltd (Hebburn)
 Bob Lisle, Charlie Alcock, John Lindsay, Tommy Kidd, Brian White, Alan Bell and Paul Crozier.
AMARC Middlesbrough
 Gordon Angel, Brian Davies
Sheffield Laser Profilers
Northern Dished Ends
Gateshead Castings
Newcastle Metal Spinners

Project Officers
Tony Noble (Project Leader), Les Hooper, Tony Duggan, Peter Davies.

Site Installation
Brian Yates, Jan Anderson, Mick Hannon.

Publication
Stephanie Smith, Richard Cork, Stephen and Sue Bland, Alison Lloyd, Henry Moore Foundation and Teesside Arts Awards.

Photographs
Attilio Maranzano – Cover and p. 4
Hans Hammarskiold – p. 10
Hazel Gall – pp. 11, 29, 54, 55, 56
K. Paver – p. 14
John Buchan – pp. 22, 34, 35
Jan Anderson – p. 22
Claes Oldenburg / Coosje van Bruggen – pp. 27 (bottom), 32
Christine Mulloy – pp. 30, 31, 38, 40, 41, 42, 43, 44, 45, 46, 47, 48, 50, 51
Tony Duggan – pp. 35, 50
Stephen Bland – pp. 52, 53
Geoffry Clements – p. 17
Dorothy Zeidman – p. 37
D. James Dee – pp. 15, 16, 19, 24, 27 (top)
Ivan Dalla Tana – p. 25

Finally, a special thank you to Claes Oldenburg and Coosje van Bruggen for giving Middlesbrough the *Bottle of Notes*.